К. Малевич

Great Modern Masters

Malevich

General Editor: José María Faerna

Translated from the Spanish by Alberto Curotto

CAMEO/ABRAMS

HARRY N. ABRAMS, INC., PUBLISHERS

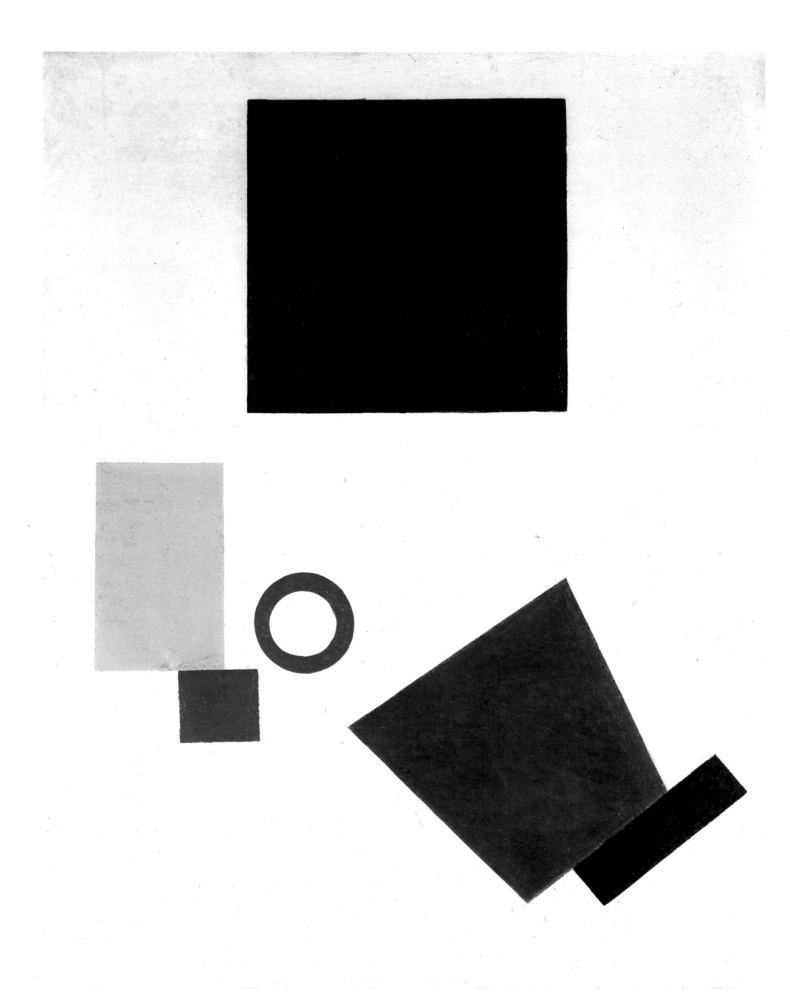

Self-Portrait in Two Dimensions, *1915. Oil on canvas, 31½ × 24⅜″ (80 3 62 cm). Stedelijk Museum, Amsterdam*

4

Malevich and the Russian Avant-Garde

The Russian Revolution of 1917 set the stage for one of the most remarkable interludes in the history of avant-garde art. Although the origins of this episode were firmly rooted in the early years of the century, the Revolution raised the hope among modern artists that they might actually realize one of their most cherished dreams: a revolutionary state, in which the avant-garde would transform the world, creating a new home for modern humanity. The consolidation of the power of Stalin in the late 1920s and early 1930s—followed by the establishment of Socialist Realism as the official Soviet style—put an end to this dream. But for a time, the hope of such a societal transformation spurred some of the boldest and most radical artistic experiments of all time.

The Specifics of Painting

This outburst of invention can be illustrated by the work of three of its leading representatives. On one hand, Vasily Kandinsky—living in Germany, but maintaining close ties to Russia—developed a highly spiritual imagery derived from nineteenth-century Romanticism. On the other, Vladimir Tatlin, the leader of the Constructivist movement, called for the artist's direct involvement in industrial production, and thus in the hands-on construction of the new society. Between these two stood Kazimir Malevich, whose intense study of the idiom of painting itself sought out its most basic fundamentals, and transcended its limits.

From the very beginning, by his own account, Malevich focused his attention on the essence of painting, that is to say, on whatever in it was not a representation of the natural world, or anything else, but simply painting. It is significant that even in childhood, the icons that he saw in his home seemed to him devoid of content: "Nobody understood that an icon was a representation of an actual person, or that color was its medium of expression. I never made any association of ideas when I looked at these paintings, and they seemed to have nothing to do with me or my life." Later, Malevich's interest shifted from the painterly idiom itself to the specific work of Cézanne, who—along with Symbolism and Post-Impressionism—was to be a constant influence on Malevich's Neo-Primitivist works until 1912.

An Experimental Art

"His distortions," Malevich wrote of Cézanne, "are not intended to change one form of an object into another, but rather to alter the viewer's perception of the pictorial elements within the object." Malevich fervently believed that Cézanne's attempt to create a new order independent of the natural one in painting was the course that modern artists should follow. Consequently, he shifted to a near-Cubist style in such works as *Woman with Buckets* or *The Harvest of the Century* (both of 1912), even though

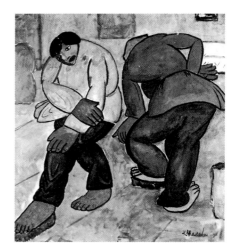

The Floor Waxers, *1911–12. Malevich's Neo-Primitivist work was strongly influenced by French Fauvism.*

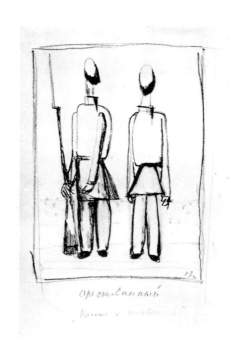

Detention. Mankind and Power, *ca. 1930. This evocative drawing may suggest the artist's troubled state of mind at the height of Stalinism.*

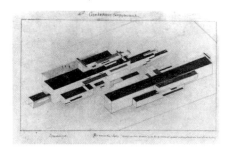

In the early 1920s, Malevich's "planits" (architectural sketches and models) were an attempt to adapt Suprematism to a three-dimensional medium.

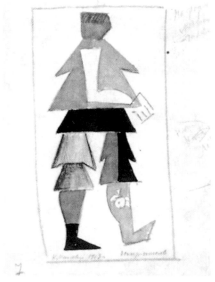

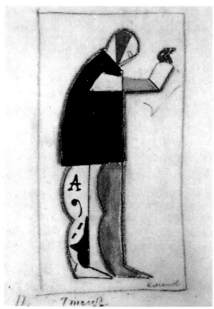

With these two costume sketches for the Futurist opera Victory over the Sun, *dating from the winter of 1913, Malevich was already laying the foundations of Suprematism.*

these paintings still retain much of the folk aesthetic typical of Neo-Primitivism. After 1912, Malevich considered himself a Cubo-Futurist, although he never shared the Futurists' mythologizing fascination with the machine. Much more significant to his artistic thinking was the influence of *zaum*, an experimental language that its creators intended to function "beyond the mind," invented by the avant-garde poets Velimir Khlebnikov and Alexei Kruchenykh, with whom Malevich was closely associated in 1913. Their aim, as stated in a manifesto that they jointly published, was "to destroy the outdated movement of thought that follows the law of causality, the nice dullness of sense, the logic of symmetry, and the aimless drifting through the blue haze of Symbolism, and to offer in its stead the creative provision of the authentic world of a new humankind." Thus *zaum* represented a state of being where perception and expression might occur without conscious thought. Malevich applied the principles inherent in *zaum* to his designs for the 1913 Futurist opera *Victory over the Sun*, as well as to his paintings of the same year, such as *Cow and Violin*, where unrelated objects are juxtaposed in a Cubist setting. These are the so-called "alogical paintings," in which Malevich's deliberate rejection of representation and the pictorial object reached its extreme.

Ground Zero

"Alogic" marked the transition from Malevich's earlier Cézannesque and Cubist styles to Suprematism, the most radical abstraction of avant-garde painting. The well-known *Black Square* of 1915, a virtual icon of Suprematism, was the endpoint of this development. The black square represents nothing and it expresses nothing. It is the "ground zero" of painting, an image reduced to its most elementary components, an empty form that conveys nothing but the stamp of the painter's hand. Such profound reductionism could not last long; gradually it gave rise to a geometrical idiom of shapes and colors, which evolved with increasing complexity through successive derivations from the elemental square. After 1918, Malevich gave up easel painting altogether to teach, and to develop three-dimensional Suprematist works, with an eye to their possible application to architecture and the production of common objects for daily use. Then, finally, in his last years, he returned to figurative representation.

"The Return to Order"

Until recently, this last stage of Malevich's career was virtually unknown in the West. The establishment of Stalinism and the rise of Socialist Realism tended to obscure the painter's reputation, and gave rise to the myth of his neglect and even persecution by Russian authorities. But there is no reason to believe that either of these was the case. It is true that Malevich was briefly detained by the police in 1930, and that official favor was gradually withdrawn. Nevertheless, the artist continued to send both Suprematist and representational works to state-sponsored exhibitions, and to enjoy the use of a studio at the Russian Museum in Leningrad. His figural work in this period may have been a coerced response to the stylistic dictates of officialdom, but this is by no means certain. It is equally likely that these paintings were Malevich's own version of the "return to order" expressed in the work of so many modern masters after World War I. In fact, his late figurative manner was a direct outgrowth of Suprematism, which he always regarded as his principal legacy to modern art.

Kazimir Malevich/1878–1935

Malevich was born in Kiev, Ukraine. While still a child, he developed an idealized vision of peasant life in contrast to the alienation of the industrial proletariat, which he had observed at the sugar refineries where his father worked. He began to paint while still in Kiev, and, in 1896, when his family moved to Kursk, found employment as a draftsman for the railroads. Soon after this, he began to paint in a Post-Impressionist manner. Establishing firm dates for the work of this period is extremely difficult, because in the late 1920s the artist made replicas of many of his early paintings, often altering not only the original compositions, but the dates as well.

In the Avant-Garde

In 1906, Malevich settled in Moscow, where he studied with Fedor Rerberg, and steeped himself in the most current contemporary painting. The magnificent art collections of the textile magnates Sergei Schuskin and the brothers Ivan and Mikhail Morozov were open for both viewing and sketching, and thus Malevich was able to see work by the French Impressionists, Seurat, and Cézanne firsthand.

In 1907 and 1908, Malevich took part in the exhibitions of the Moscow Artists' Society, as did a number of other painters who would eventually prove to be key figures in Russian contemporary art, including Natalia Goncharova, Mikhail Larionov, and Kandinsky. Beginning in 1908, at the exhibitions sponsored by the journal *Golden Fleece*, Malevich was able to see works by the French Fauvists, as well as Braque's *Great Nude*, the first Cubist painting ever shown in Russia. In 1910, he began to exhibit with a number of artists' groups, including The Jack of Diamonds, The Saint Petersburg Youth Union, and The Donkey's Tail, becoming acquainted with the foremost figures of the Russian avant-garde: Tatlin, Barbara Stepanova, Marc Chagall, and the Burliuk brothers, all Primitivists, on whom Cézanne was the dominant influence.

Cubo-Futurism

Although Malevich preferred to call himself a Cubo-Futurist, between 1912 and 1915 he joined the Russian Futurist group, whose first manifesto, *A Slap in the Face of Public Taste*, was published in 1912 by David Burliuk, and the poets Kruchenykh, Khlebnikov, and Vladimir Mayakovsky. Malevich's involvement in the avant-garde intensified in 1913 with the premiere of *Victory over the Sun*, a Futurist opera with a libretto by Kruchenykh and music by Mikhail Matiushin. The sets and costumes, which Malevich designed, already showed signs of the radical abstraction that the artist would later develop into Suprematism. Malevich was also involved with Khlebnikov's and Kruchenykh's experiments with *zaum*, a theoretical language "beyond the mind," and these "alogical" experiments provided an intellectual link between his Cubo-Futurist paintings—*An Englishman in Moscow* and *The Aviator* (both of 1914)—and his later Suprematist works.

Kazimir Malevich as portrayed by Yuri Annenkov in 1917, at the height of the development of Suprematism.

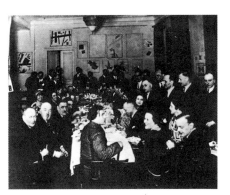

A reception in Malevich's honor during a visit to Warsaw, on his way to Germany, in 1927.

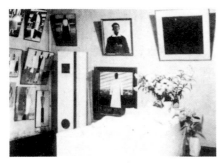

Malevich lying in state in his Moscow apartment. Behind him, his Black Square, *exhibited as a funerary icon.*

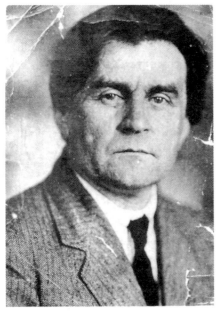

One of the best known photographs of Malevich, dating from around 1925, when he was director of the Petrograd GINKHUK.

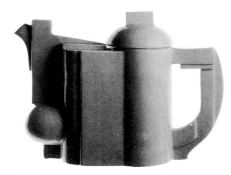

A Suprematist teapot designed by Malevich and manufactured in 1923 by the Lomonosov State Porcelain Factory.

Suprematist Abstraction

During World War I Malevich designed propaganda posters in the manner of *lubok*, traditional Russian colored engravings with captions (which, in this case were provided by the poet Vladimir Mayakovsky), but these had little to do with his overall development. In his other work, he continued toward the rigorous, geometric abstraction that he would call Suprematism. He showed his first works in this style in 1915 at the Futurist exhibition "0.10 (Zero–Ten)." Among them was the famous *Black Square*. Futurist artists, such as Ivan Puni and Ivan Kliun, enthusiastically embraced the new current, which Malevich expounded in an essay, *From Cubism to Suprematism: the New Pictorial Realism*. With the Revolution of 1917 the artist joined the revolutionary fervor of the avant-garde both with his own writings and by assuming new responsibilities as a museum director and teacher.

In 1919, Malevich began to teach at the Vitebsk Art School, which was then directed by Marc Chagall. Chagall, however, had no interest in Suprematism. In 1920 he resigned from his position in favor of Malevich, who, with the help of Lazar (El) Lissitzky, Ilia Chashnik, and others, renamed the school UNOVIS, a Russian acronym for "Advocates of the New Art." This new enterprise lasted until 1922, when it was forced to close down for lack of support from the Moscow INKHUK, the Institute of Artistic Culture, which was then dominated by the Constructivists.

In 1923, Malevich was appointed director of the Petrograd Museum of Artistic Culture. Although his work continued to be shown in Berlin and Amsterdam, he now abandoned easel painting to devote himself to a new form of design, which he called "planits" or "architectonics." These were sculptural models for modern houses, conceived as three-dimensional geometrical structures to be made of concrete and glass, with electric heating units built into the walls to eliminate dirt and clutter. Indeed, Malevich's work was increasingly pragmatic, and he was eager to apply Suprematism to industrial production, as when he collaborated with the Lomonosov State Porcelain Factory in Petrograd in the design of tableware. Preoccupied with experiments of this kind, Malevich established laboratories for developing industrial designs at the museum, and changed its name to the Petrograd State Institute of Artistic Culture, or GINKHUK. Tatlin, who had always been interested in practical applications of art, also taught there until 1925. In June 1926, however, GINKHUK came under attack in the leading Communist party newspaper as a "government-supported monastery" rife with "counterrevolutionary sermonizing" and "artistic debauchery." Malevich soon lost his position as director, and the institute was forced to close at the end of that year.

Under the Black Square

After Lenin's death, the Soviet state adopted of Socialist Realism as the official Soviet style for painting and sculpture. Nonetheless, in 1927 Malevich traveled in an official capacity to Poland and Germany, where he met a number of Western Europe's avant-garde artists. When he returned to Russia, he left a group of paintings in Berlin that were essentially the only works by him known in the West for many years. In the last ten years of his life, he reverted to figural painting, perhaps as an act of renewal following the cleansing refinement of Suprematism. Although now out of official favor, Malevich was nevertheless highly regarded. His funeral in Leningrad was a mass rally—possibly the last one of the Russian avant-garde—under the banner of *Black Square*.

Plates

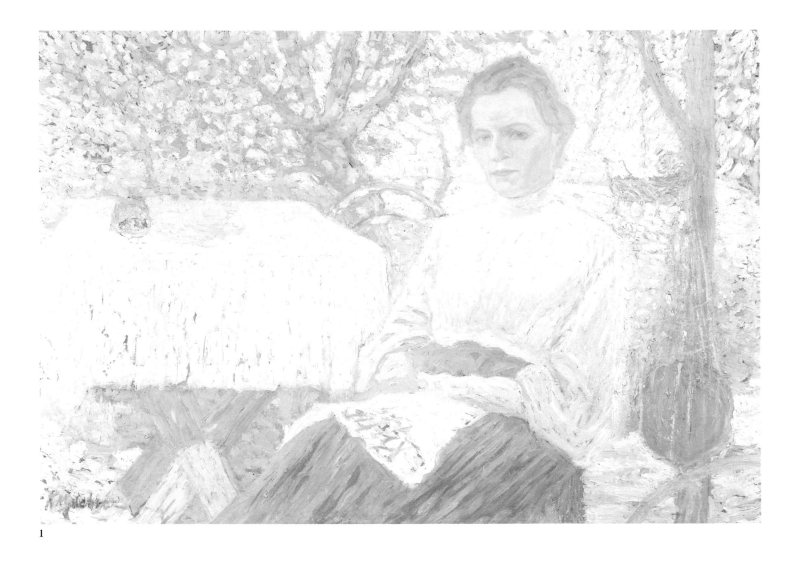

1

Cézanne and Neo-Primitivism

Before 1910, Malevich's painting bore the mark of French Post-Impressionism—notably the work of Seurat and the *Nabis*—as well as the decorative stamp of Symbolism. Cézanne's influence can be seen in the rigor of the young artist's early compositions, which also reflect the chromatic brilliance and freedom of the French Fauvists. Like Mikhail Larionov and Natalia Goncharova, among others, Malevich applied these same principles to the treatment of peasant themes. His paintings of these subjects also show the influence of Russian icons, and of the popular folk prints called *lubok. Lubok* were colored engravings—often of legendary or historic subjects, accompanied by explanatory captions—which had enjoyed widespread popularity in Russia since the eighteenth century.

This early style, which is known as Neo-Primitivism, evolved between 1910 and 1913 in the shows of such groups as The Jack of Diamonds and, especially, The Donkey's Tail. The latter group had gathered around Larionov in 1912, and exhibited works by Malevich, Chagall, Vladimir Tatlin, and Barbara Stepanova. Malevich's Neo-Primitivist paintings of this period still show their debt to Cézanne's volumetric style, even as the young Russian's work was rapidly evolving toward full-blown Cubism.

1 Portrait of a Member of the Artist's Family, *1906. The light palette and the delicate Impressionist technique evoke the work of Bonnard and Vuillard, two of the French artists most favored by Russian collectors of modern painting in the early years of the century.*

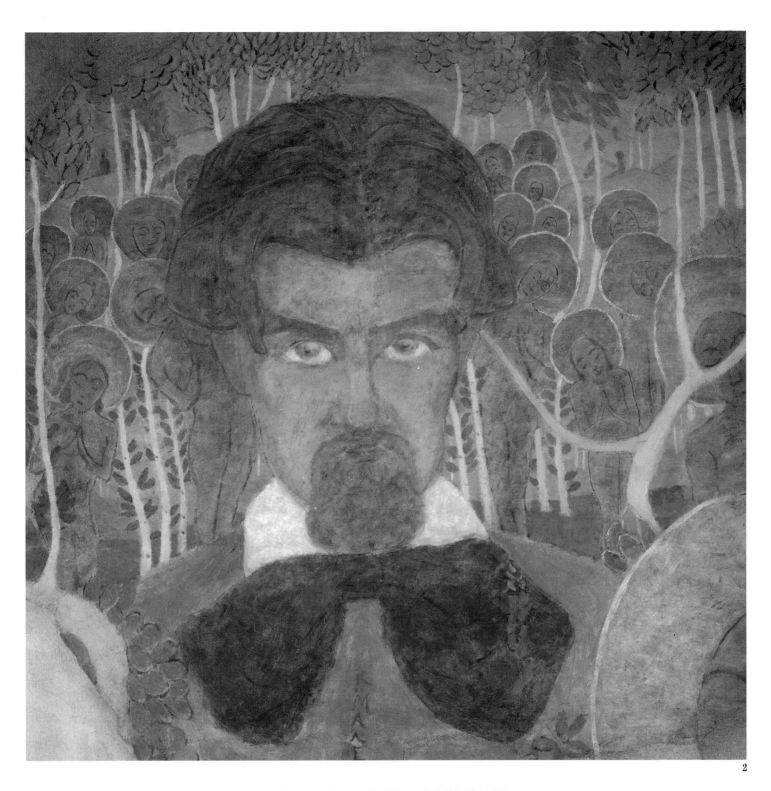

2 Study for a Fresco (Self-Portrait), *1907. Malevich
completed a series of works with this title during the
year that he began showing his work at the Moscow
Artists' Society. These paintings are characterized by
a clear Symbolist influence. The composition, with
its variations in scale and its small background
figures, recalls traditional Russian icons, which were
a constant influence on Malevich's art throughout his
career.*

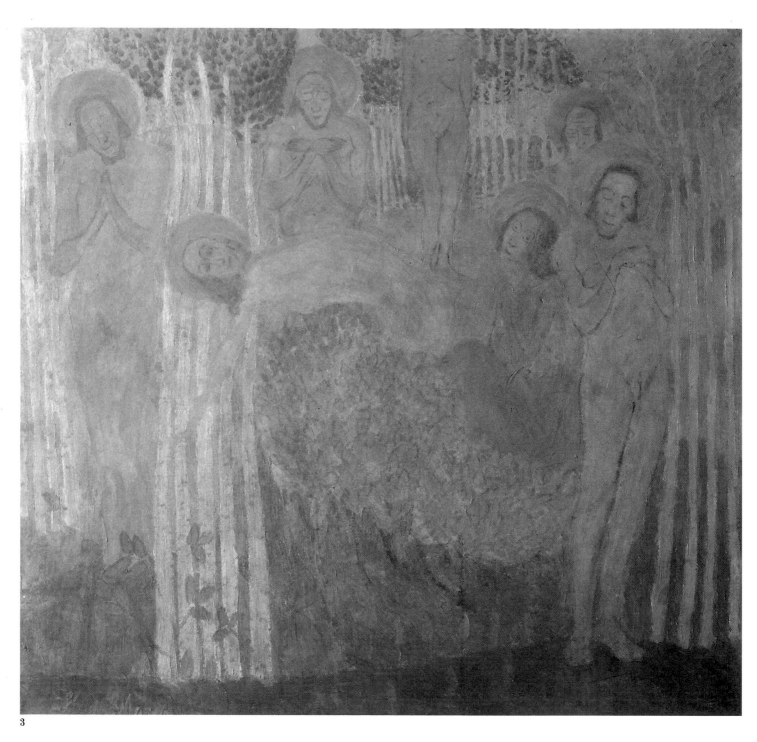

3

3 Study for a Fresco, *1907. The flattened calligraphy and the vaguely religious message of these paintings are reminiscent of Maurice Denis and the Nabis, and even more of Odilon Redon. Redon's work was widely known in Russia in this period, through the art review* The Balance, *which published pictures of his paintings and of those exhibited in the shows of such Symbolist groups as Pink Blue or The Garland. Malevich, recently arrived from his native Ukraine, was deeply impressed by these paintings.*

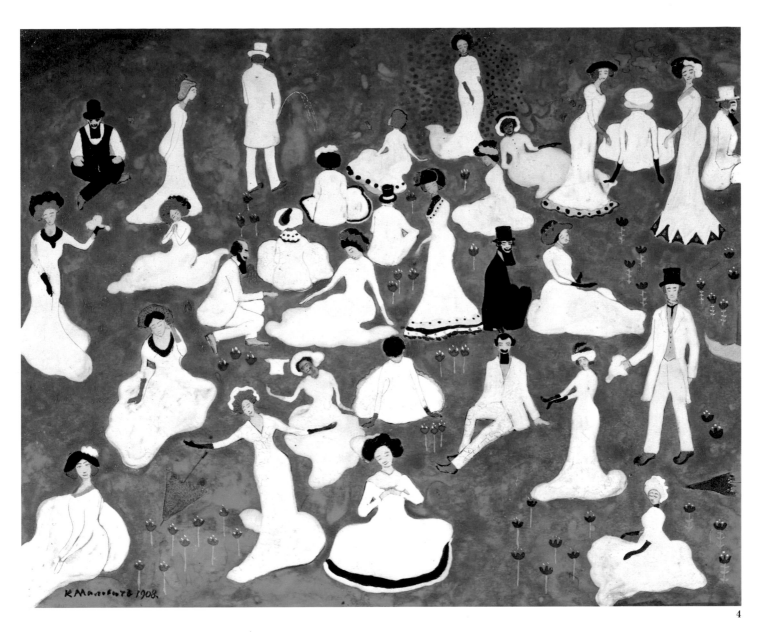

4

4 The Leisure of High Society, *1908. With its figures spread out over a flat green background, this is possibly the most decorative, fin-de-siècle work that Malevich ever painted. Such humorous touches as the man urinating at the upper left suggest a certain social irony, not surprising since the artist had been actively involved in the revolutionary events of 1905.*

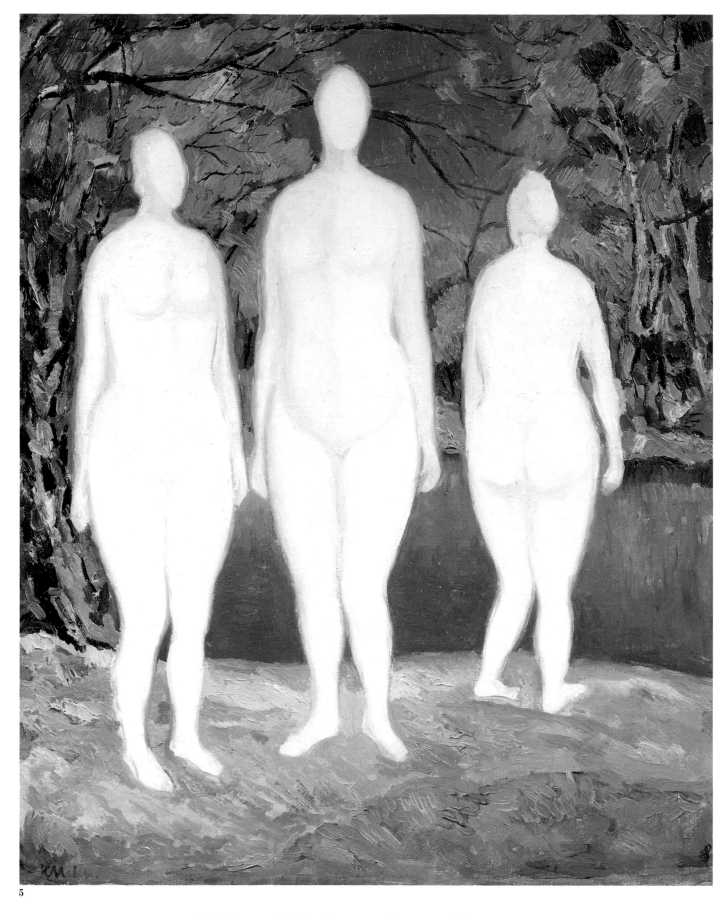

5

5 Bathers, *ca. 1908. A reference—and homage—to Cézanne is suggested by these three nudes, whose blank faces anticipate the featureless figures in Malevich's late paintings. The use of brushstrokes to suggest spatial directions is likewise derived from the example of Cézanne.*

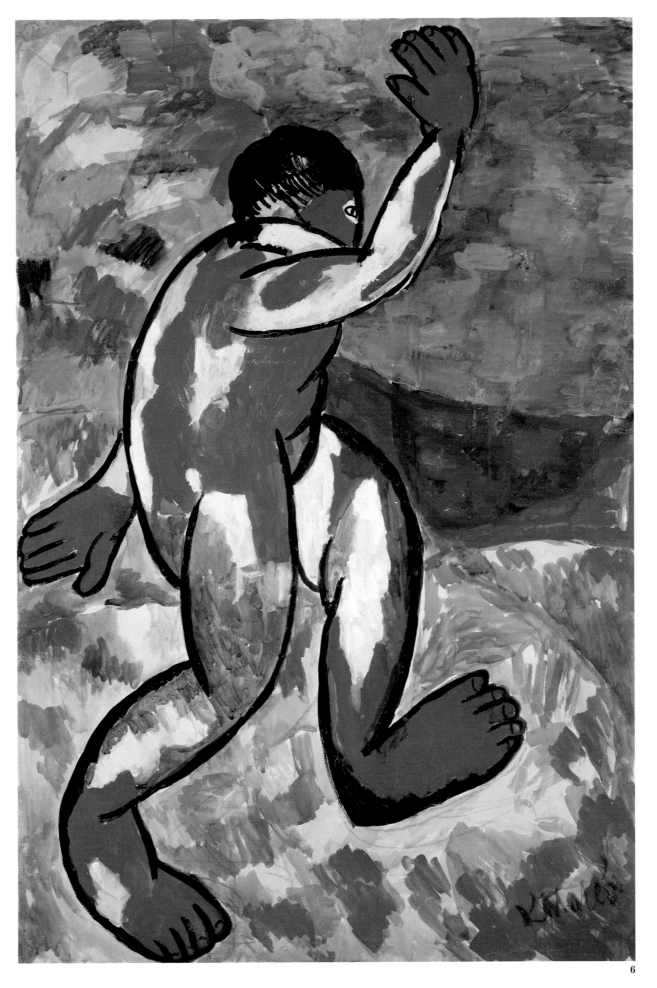

6

6 Bather, *1911. In his search for the "specifically painterly,"
Malevich increasingly avoided representational elements, and
began to distort his figures. Here, his Cézannesque subject is
presented with the arbitrary color of the French Fauvists.*

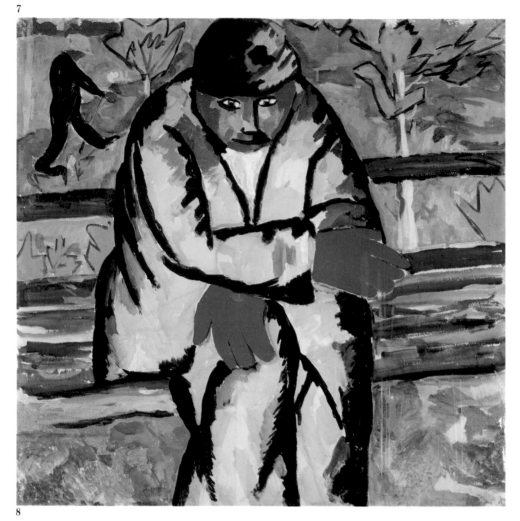

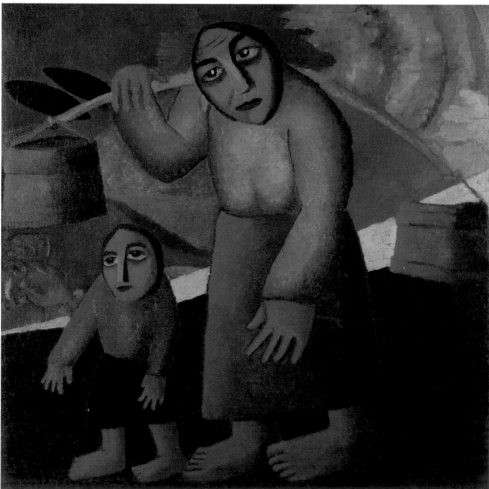

7, 8 On the Boulevard, *1911*. Peasant Woman with Buckets and a Child, *1912. These paintings exemplify two distinct facets of Malevich's Neo-Primitivism.* On the Boulevard *depicts, in a Fauvist idiom, the alienation of the urban proletariat, with which the artist had become well acquainted during his childhood, in the sugar refineries where his father worked. In* Peasant Woman with Buckets and a Child, *the painter pushed the Cézannesque formal synthesis almost to the point of Cubism, while adopting the hieratic faces with almond-shaped eyes of Russian icons.*

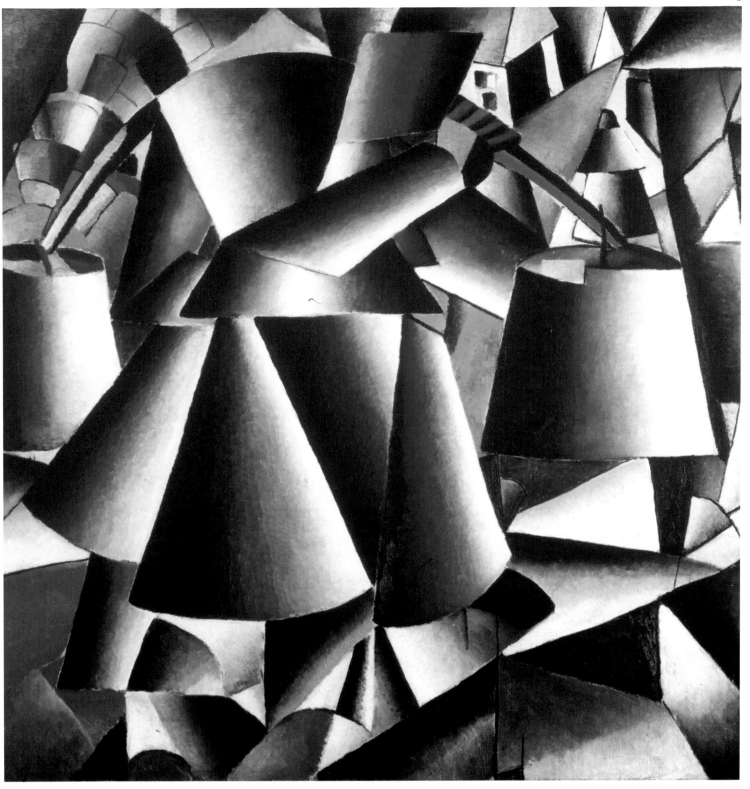

9 Woman with Water Pails: Dynamic Arrangement, *1912-13. Although the subject of this painting is the same as the previous one, its formal treatment is now thoroughly Cubist. Despite its similarities to Léger's work, Malevich is still developing what he has learned from Cézanne. Possibly no other painting as clearly attests to*
the ease with which the artist shifted from Neo-Primitivism to the Cubo-Futurist idiom of the years to follow.

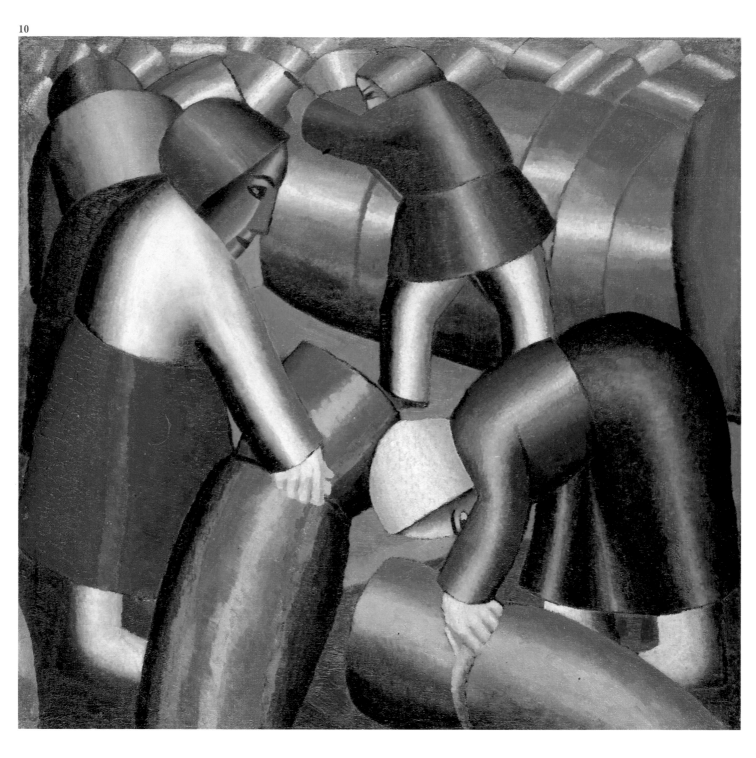

10 The Harvest of the Century, *1912. Malevich
believed that the mere existence of folk art was
evidence of the fact that the peasantry had managed
to avoid the alienation of the industrial proletariat.
The formal and chromatic synthesis of these
paintings combines references to lubok—colored folk
engravings—and traditional icons with the modern
formalism of Cézanne.*

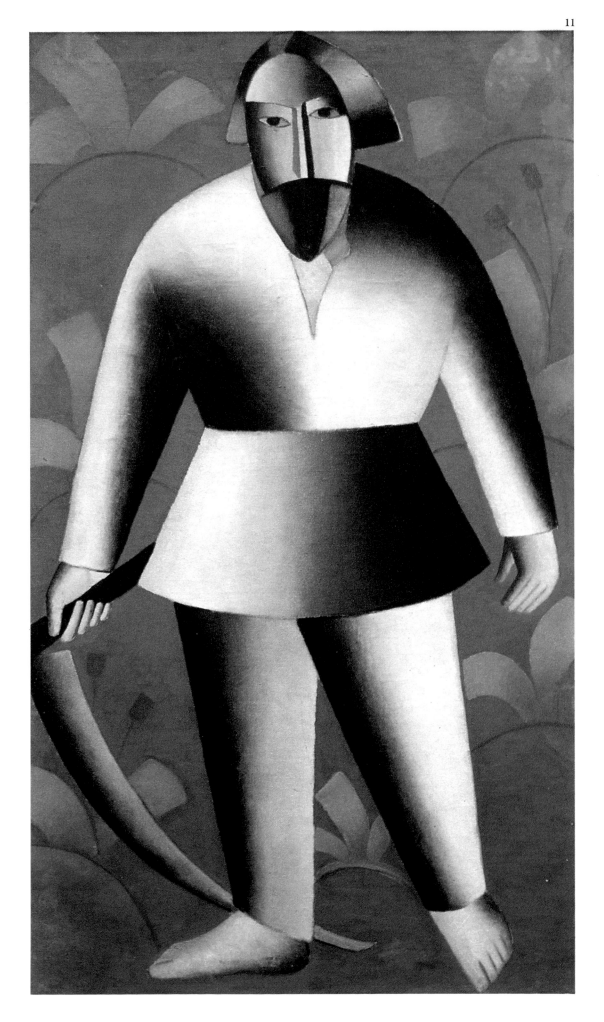

11 Reaper against a Red Background, *1912–13. Here a Neo-Primitivist figure is set against an abstract pattern of vegetative motifs. The monumental form of the reaper seems to combine the qualities of a modernized icon and a Futurist robot. A comparison with the figures of Giorgio de Chirico's metaphysical paintings is almost irresistible.*

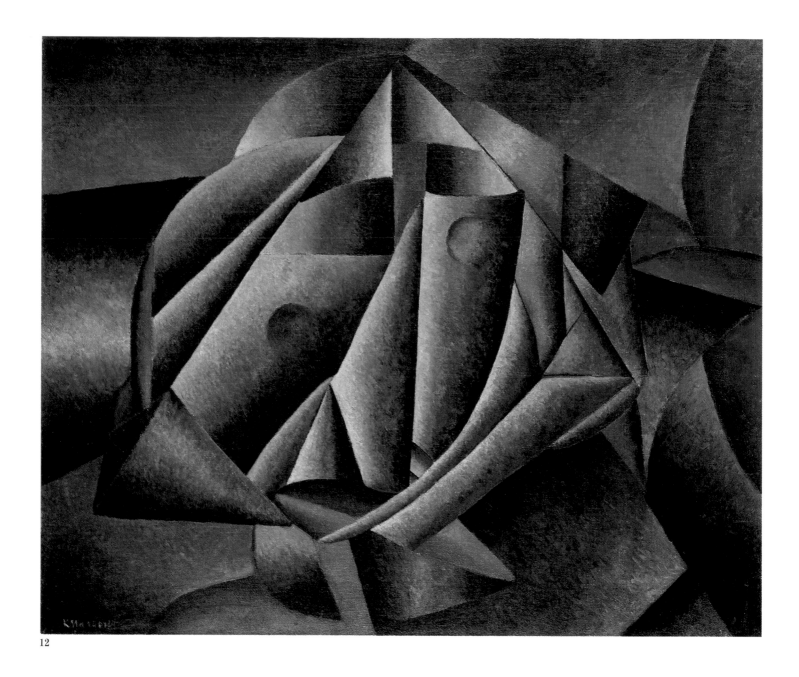

12

Cubism, Futurism, and *Zaum*

Malevich easily assimilated the Cubist idiom of faceted color planes. While at first strongly influenced by Léger, he soon moved the new artistic language toward his own interests, rejecting the traditional use of painting to represent nature. Between 1913 and 1915, he was actively involved with the influential Futurist groups of prerevolutionary Russia, along with the poets Kruchenykh and Khlebnikov and the composer Mikhail Matiushin. From these colleagues, Malevich absorbed the ideals of *zaum*, especially the notion of exploding the logic of representationalism. Thus, he complemented the Cubo-Futurist construction of painting with the arbitrary and absurd association of objects in a radical version of the Cubist collage. His aim was to subvert any attempt by the viewer to seek external references in his imagery. These "alogical" paintings, which he exhibited in a number of Futurist venues, laid the ground for the strict, geometrical style that he would call Suprematism.

12 Head of a Peasant Woman, *1912–13. While the subject is Neo-Primitivist, the style of this painting is very close to that of analytical Cubism. The figure and the background merge to create a single pattern of faceted planes, modulated by a limited chromatic range of greens and reddish ochers.*

13 Portrait of Ivan Kliun, *1912–13. This portrait of Malevich's friend Kliun, another prominent figure of the Russian avant-garde, retains the geometrically solid volumes of Neo-Primitivism, but treats them abstractly. Once again Malevich has adopted the frontal character of an icon, as well as the idea of the face as a mask, with the nose marking the axis of symmetry with three colored stripes, as in* Reaper against a Red Background *(no. 11).*

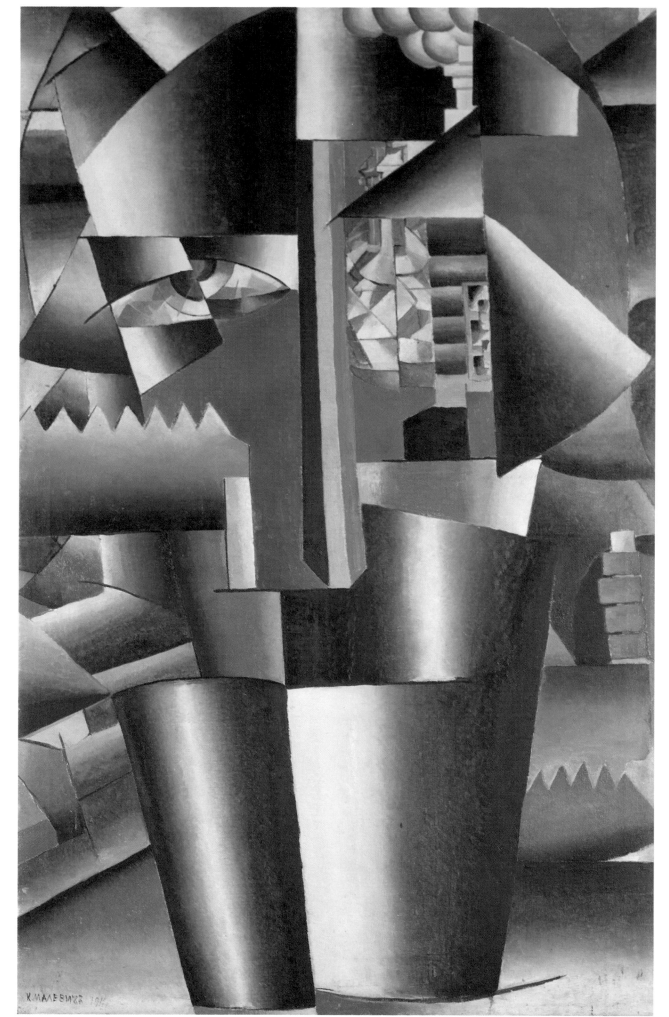

13

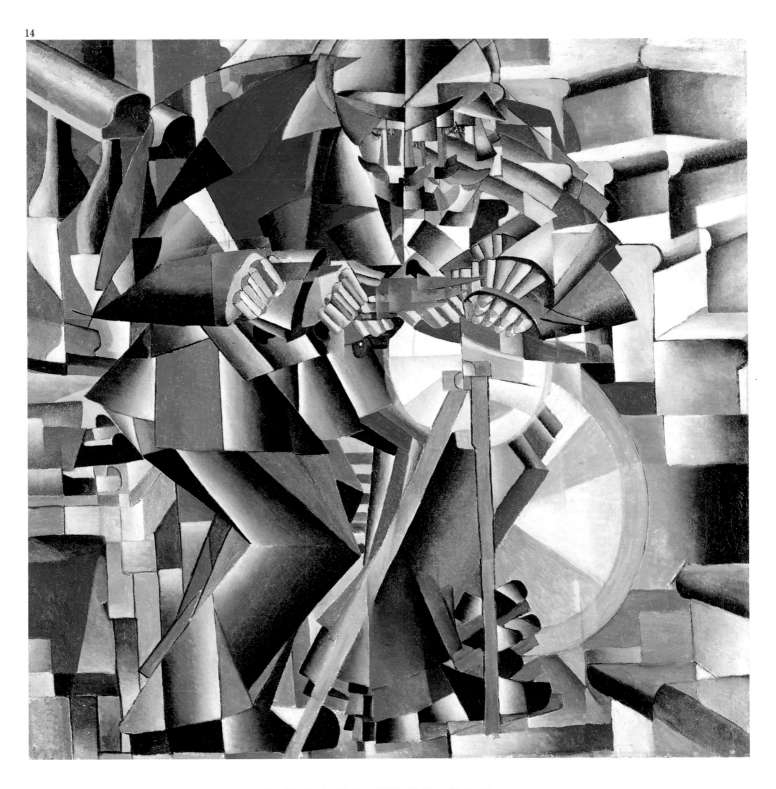

14 The Knife Grinder, *1912–13. Here, Malevich
approximates an expression of movement typical of
the Italian Futurists. The rotation of the grindstone
seems to have generated a breakdown of the
painting's formal structure into tiny color planes.
The repetition of legs, arms, and head in different
positions is a Futurist device for expressing
dynamism.*

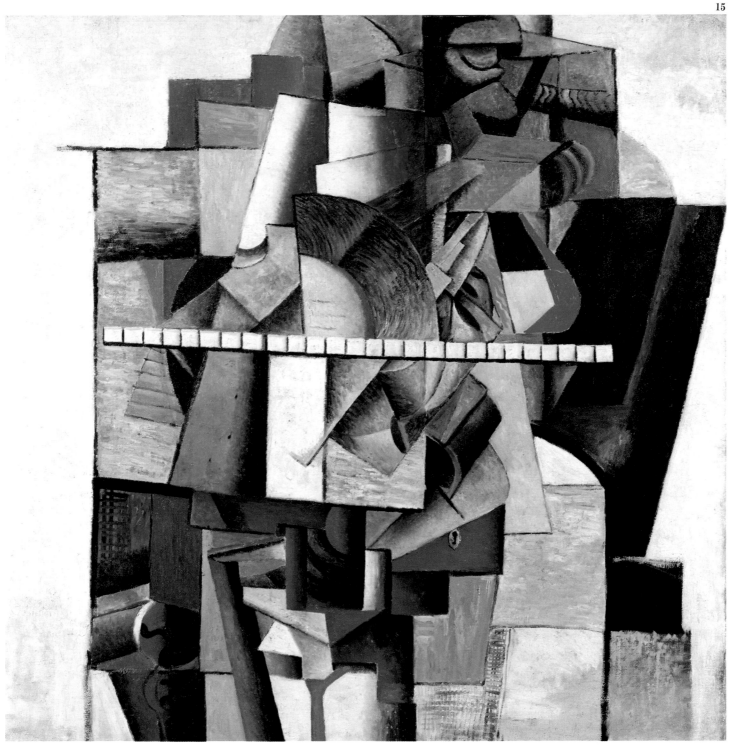

15 Portrait of Mikhail Matiushin, *1913. Malevich's Cubism was becoming increasingly more planar and less representational. A fragment of forehead and part of the hair are the only representational references to the composer of the Futurist opera,* Victory over the Sun, *for which Malevich designed the sets and costumes. The abstract keyboard that bisects the composition evokes the sitter's occupation, while the various surface textures and the trompe l'oeil keyhole reinterpret the Cubist notion of "object-painting," proclaiming the artist's independence from natural appearance.*

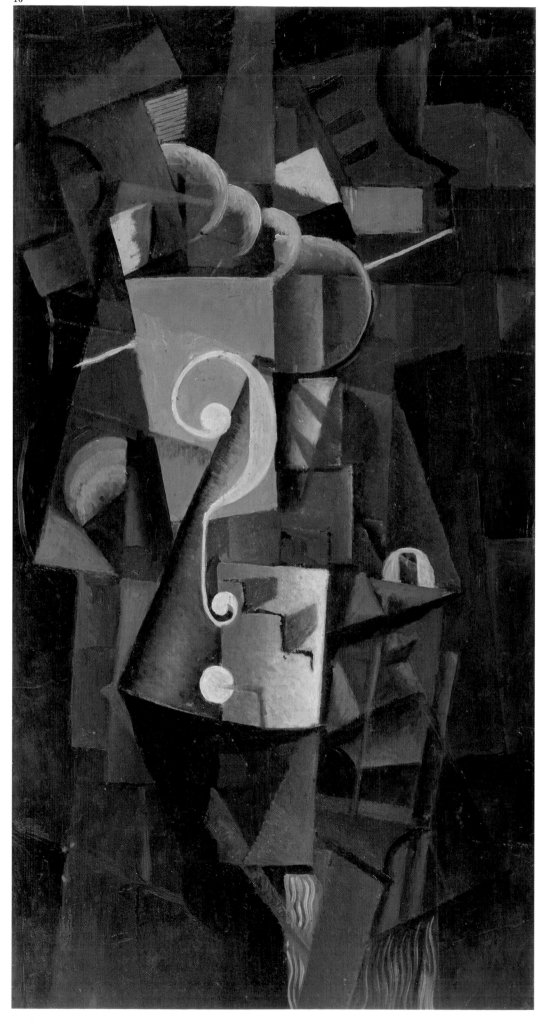

16 Transit Station: Kunsevo, *1913. Malevich progressively refined his style by moving toward greater abstraction. Here the color planes obliterate any sense of depth, although the grouping of forms at the center do suggest projection. Malevich continues his technical experimentation—he made the undulating grooves at the lower right by incising the wet paint surface with a comb—adding such humorous touches as the large question mark superimposed on the*

17 Cow and Violin, *1913. Here Malevich has used paint to imitate the Cubist technique of collage, even using the grain of the wood panel to suggest the surface of the violin. While the overlapping of colored shapes seems to flatten the composition, there are some paradoxical spatial effects, such as the shadow of the violin neck cast against the white rectangle. Within this Cubist frame of reference, the representations of the cow and the violin emphasize the painting's abstract autonomy.*

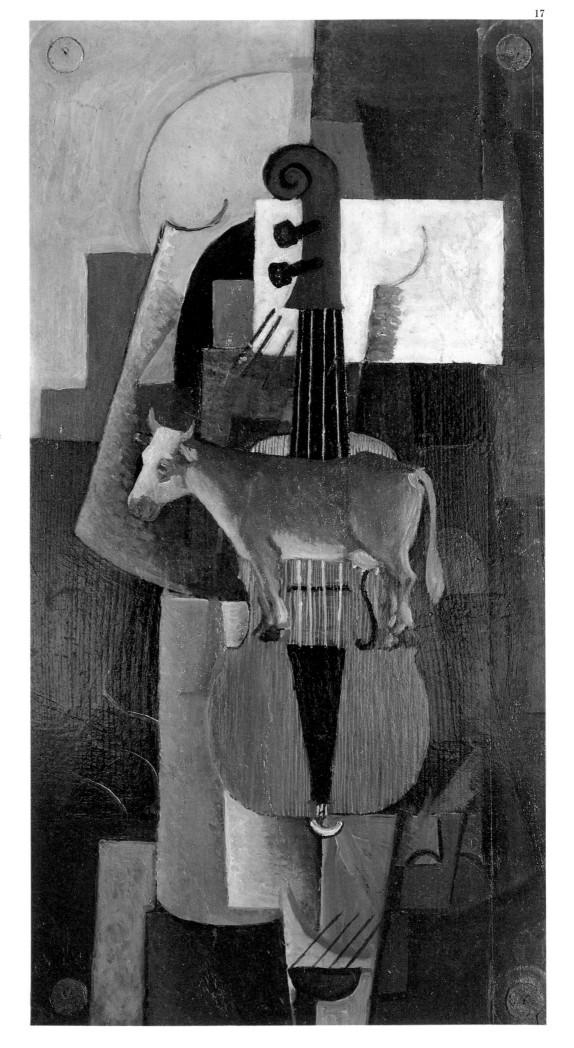

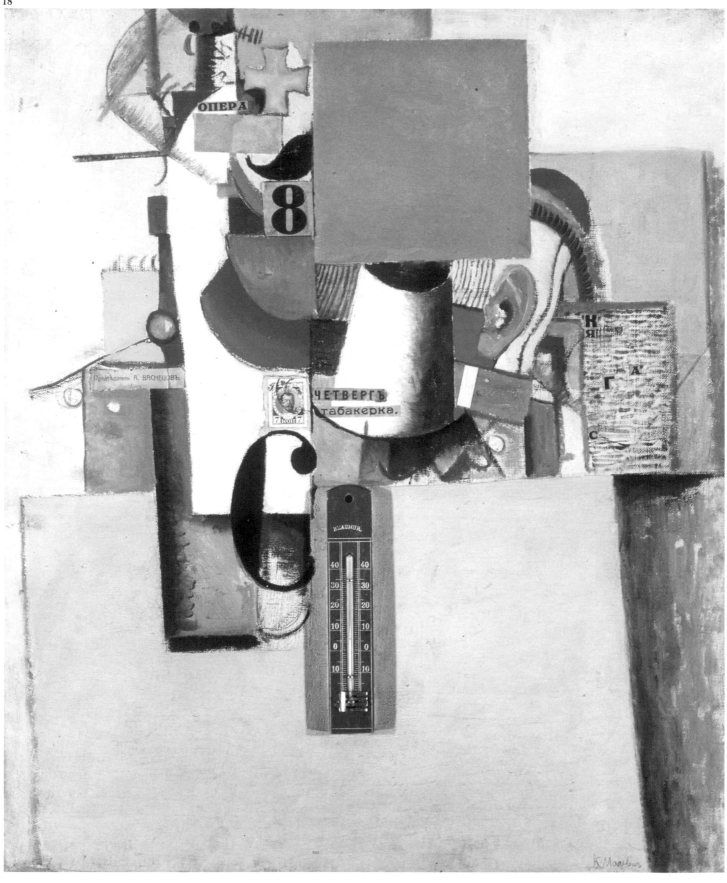

18 Private of the First Division, *1914. The two years immediately preceding Malevich's final breakthrough to Suprematism witnessed the growing importance in his art of large blocks of color, like the blue and yellow squares in this painting. A new pictorial order seems to be emerging from the Cubo-Futurist collage that occupies most of the upper half of the canvas, which incorporates a number of diverse elements—a thermometer, a stamp, letters, numbers, and ironic scraps of conventional representation, such as the soldier's ear, and the cross, which suggests a military decoration.*

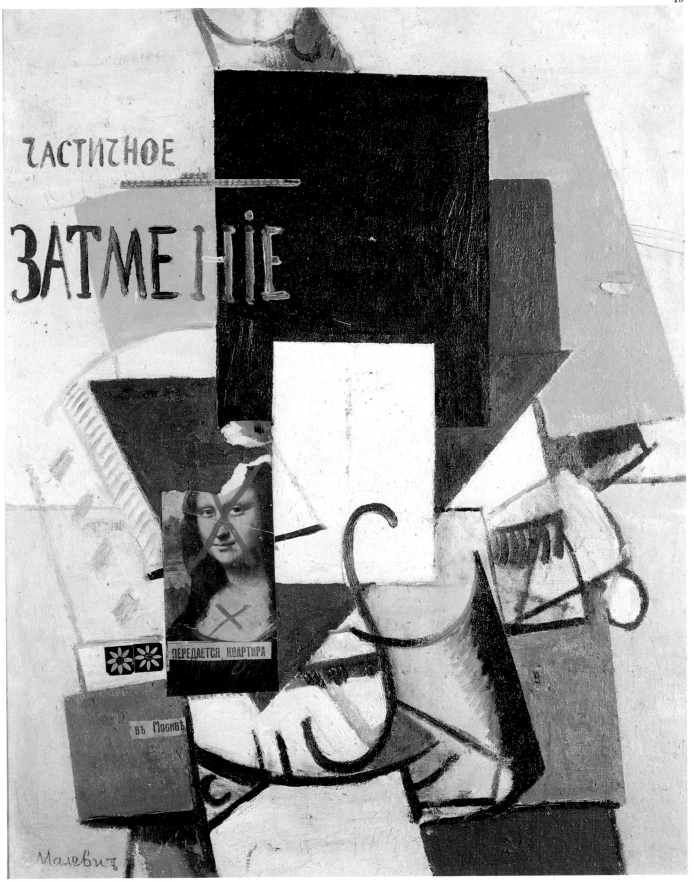

19 Partial Eclipse with Mona Lisa, *1914. The conception of this
collage is analogous to the preceding one. "The depiction of a face
in a painting is a pitiful parody of life," wrote Malevich, possibly
thinking of the features of Leonardo's portrait as they appear here.
This collage is even more ironic than the former; the "partial
eclipse," referred to in the title and the painted inscription on the
upper left, have an acerbic counterpart in the torn and crossed-out
picture of Mona Lisa, with its two printed and pasted-on
inscriptions that read "vacant apartment" and "in Moscow."*

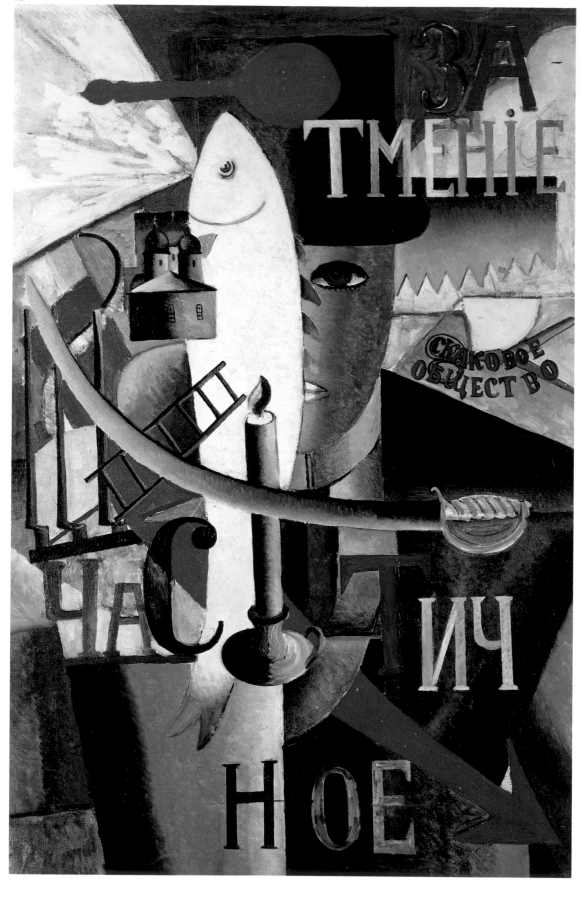

20, 21 An Englishman in Moscow, *1914*. The Aviator, *1914. Two classic examples of the transposition of* zaum *to the painterly realm, these works are the "alogical" portraits, respectively, of Alexei Kruchenykh and Vasily Kamenski, two of the most important Futurist poets. With a formal grammar of Cubist derivation, although incorporating elements that he would soon exploit more fully in his Suprematist works, Malevich combines anonymous mannikins with objects and inscriptions, some directly related to the sitters, and others that are not easily explained. The effect, comparable to that of Dadaist collages, is quite simply the dismantlement of the traditional signifying mechanisms of painting. "For the artist," wrote Malevich, "reason is a form of imprisonment."*

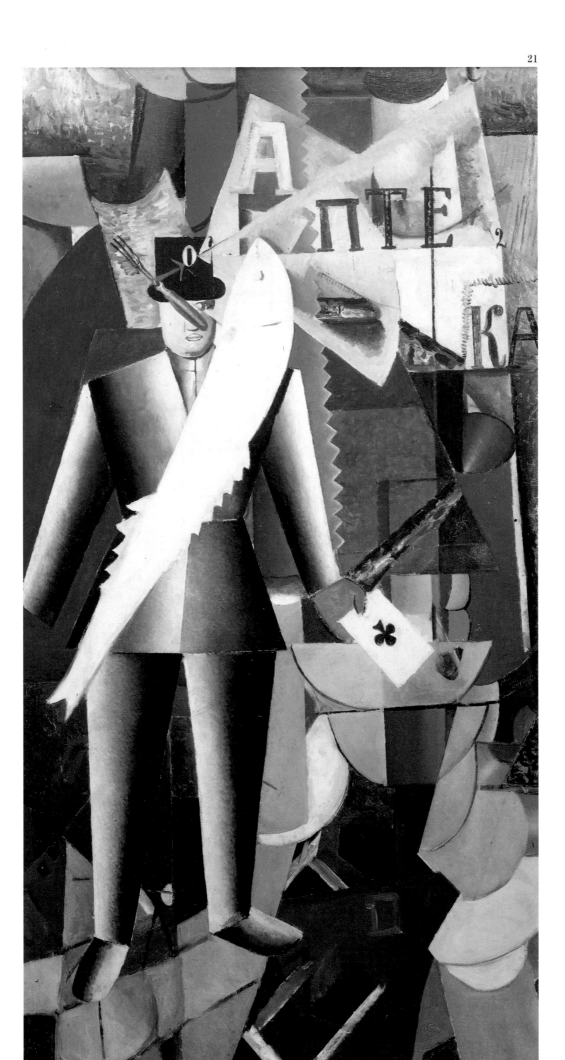

The Face of Time

In December 1915, Malevich took a definitive step that he had been considering for at least two years. He submitted to the exhibition "0.10 (Zero–Ten)" a series of entirely abstract paintings that soon came to be known under the label of Suprematism. The most radical of these was *Black Square*, simply a square surface covered with black oil paint, set against a white background. According to Malevich, the painting was "a totally bare icon with no frame"; a universal image, from which any reference to the natural world or any specific object has been eliminated; a terminus; a *tabula rasa*, on which the history of painting could be rewritten. Khlebnikov perceptively called it "The Face of Time." In the years immediately following, Malevich continued to work in this austere, highly abstract vein, deriving a variety of circles and rectangles from his original image, and, from its primordial black and white, a chromatic vocabulary of reds, yellows, and blues. In his view, he was inventing a pictorial language for a new world. And indeed, two years later, his dream of a new world seemed to materialize in the October Revolution.

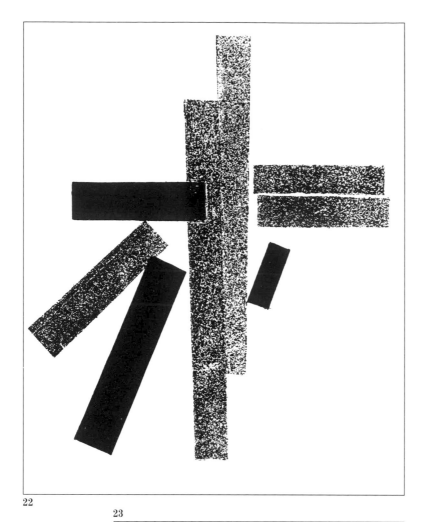

22

23

22, 23 *Two lithographs from* Suprematism, 34 drawings, *1920. Malevich completed this series of prints in Vitebsk—where he was the director of the Vitebsk Art School, later reorganized and renamed UNOVIS—with essentially educational purposes. With them, he was trying to spell out the Suprematist principle of generating forms on a plane.*

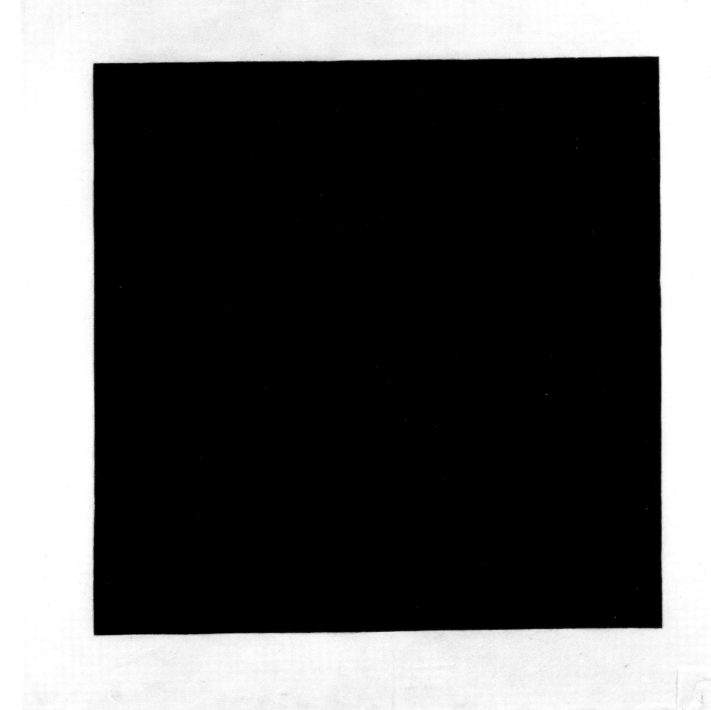

24 Black Square, *1923–29. Malevich painted several versions of this, his most emblematic work, which he later chose as the banner for his own funeral. Painted entirely freehand, without the aid of a template or straightedge, it was intended as a vacant image, which would, however, carry the mark of the painter's hand in its brushwork. In fact, a close inspection clearly reveals a number of formal and surface irregularities. Malevich always looked upon this work as an icon; in several of his exhibitions, it was hung on the wall at an acute angle—as traditional religious images were hung in Russian homes—and in a corner of the room, as if to create a sacred niche.*

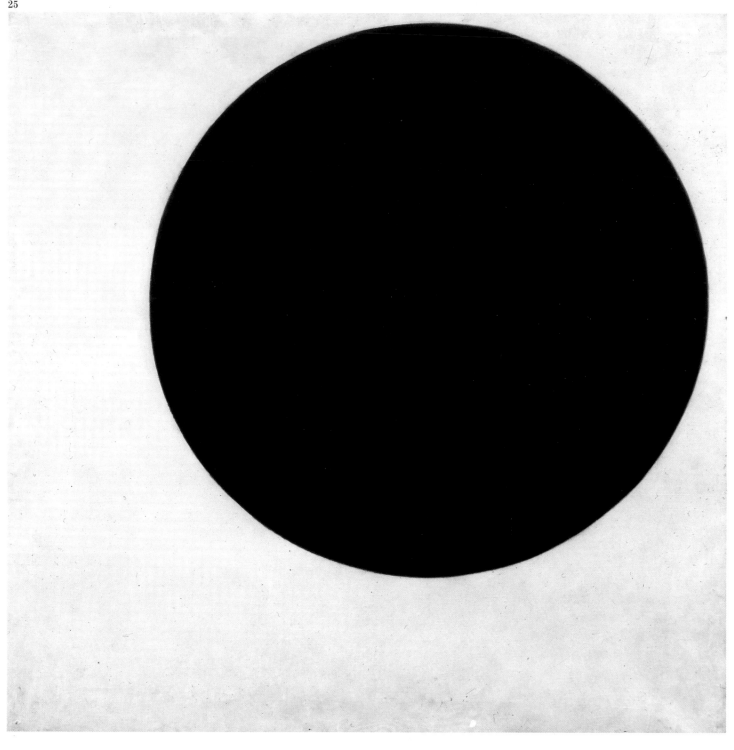

25 Black Circle, *1923–29. This is a later version of
a painting first exhibited at "0.10 (Zero–Ten)" in
1915. The circle is generated by the rotation of the
square over the surface, and thus represents the first
and most basic step in Malevich's new pictorial
idiom, which was to be unrelated to perception or
any representational impulse. The fact that the circle
is not centered on the white background confirms the
reductive nature of this image, which carries no
meaning beyond the mark of the painter's hand.*

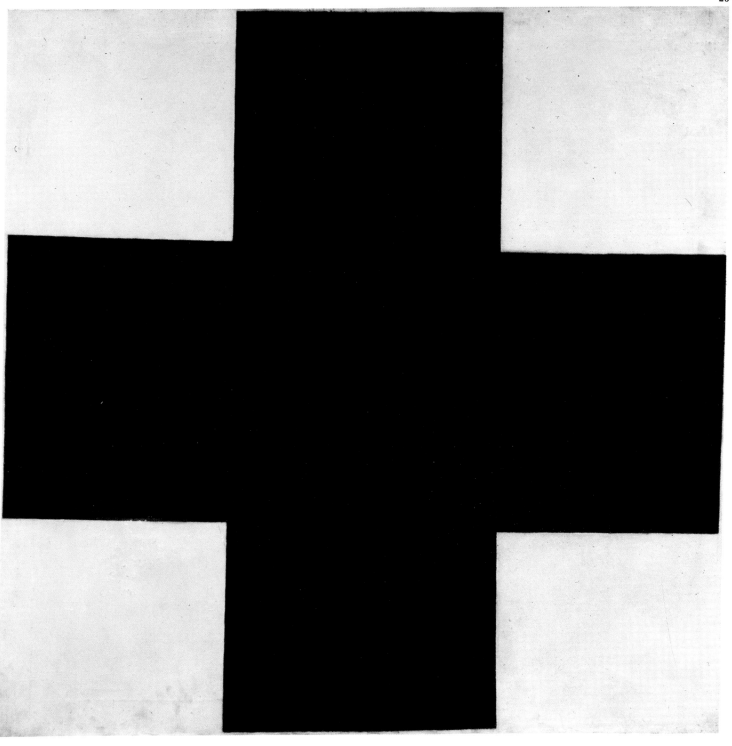

26 Black Cross, *1923–29. The extension of the square along its horizontal and vertical axes produces a cross. Here Malevich generates a purely two-dimensional space, thus realizing the ambition of modern painters to be consistent with the conditions of the pictorial surface. As in* Black Circle, *the figure is not geometrically regular. Like the two previous examples, this, too, is a later version of a painting first shown in 1915 at "0.10 (Zero–Ten)."*

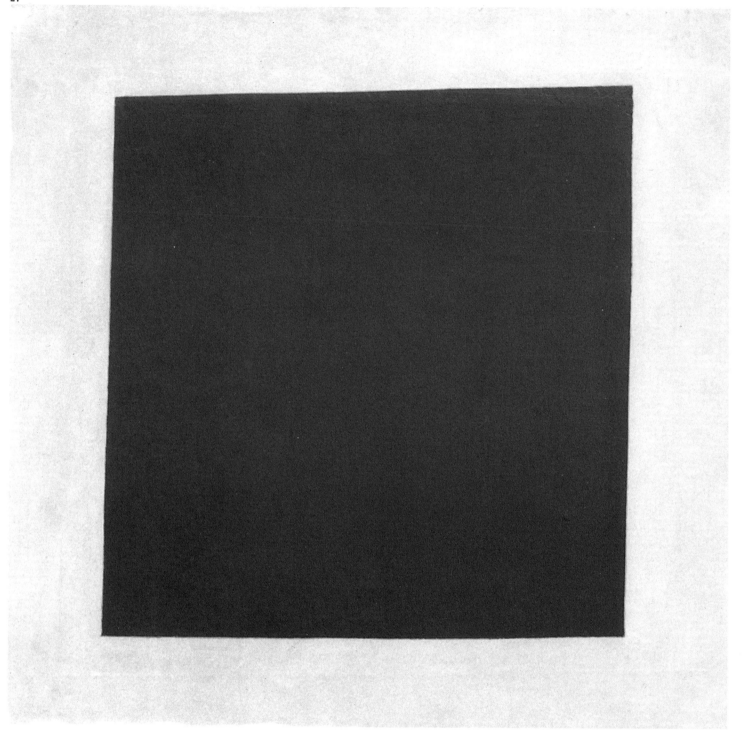

27, 28 Red Square, *1915. Painterly Realism. Boy with Knapsack—Color Masses in the Fourth Dimension, 1915. Red was the first color that Malevich added to the Suprematist palette after the original black and white. This work gave rise to a number of speculations concerning its possible symbolism, for Malevich had given* Red Square *the subtitle "Painterly Realism of a Two-Dimensional Peasant Woman." One should not forget, however, that "painterly realism," as the artist himself at times called Suprematism, to Malevich meant, not realism in the conventional sense, but "painting constituting its own objective."*

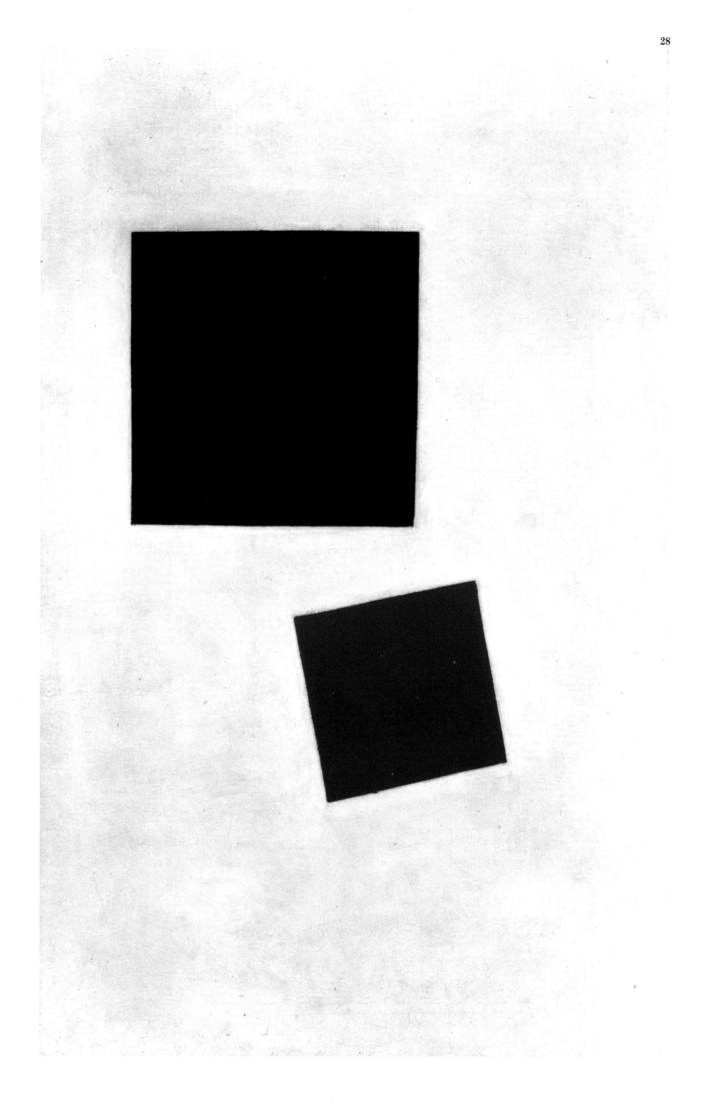

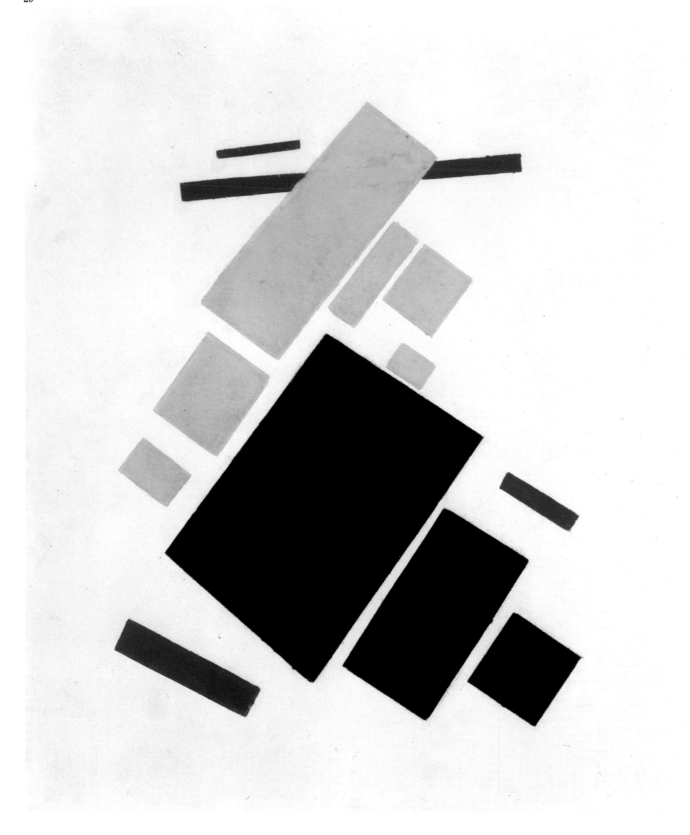

29 Suprematist Composition: Airplane Flying, *1915.*
Black and yellow rectangles are set together in two
groupings along one of the painting's diagonal axes.
One of the yellow forms overlaps a horizontal red
band, augmenting the pictorial space without
compromising the planarity of the painting's
surface.

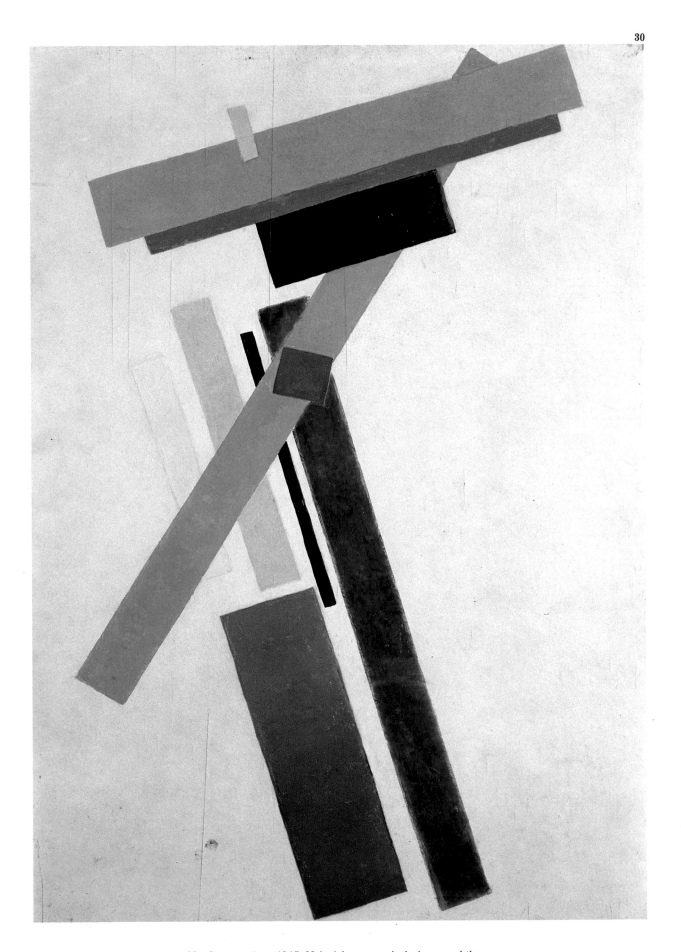

30 Suprematism, *1915. Malevich progressively increased the*
vocabulary of his new idiom as if he were introducing the letters
of a new alphabet. His shapes, at first planar and approximately
regular, were all derived from the primal square, but their
organization suggested tension and surface movement, attained
through the use of the painting's diagonals, or, as here, such focal
points as the small red square on which the other rectangles seem
to be pivoting.

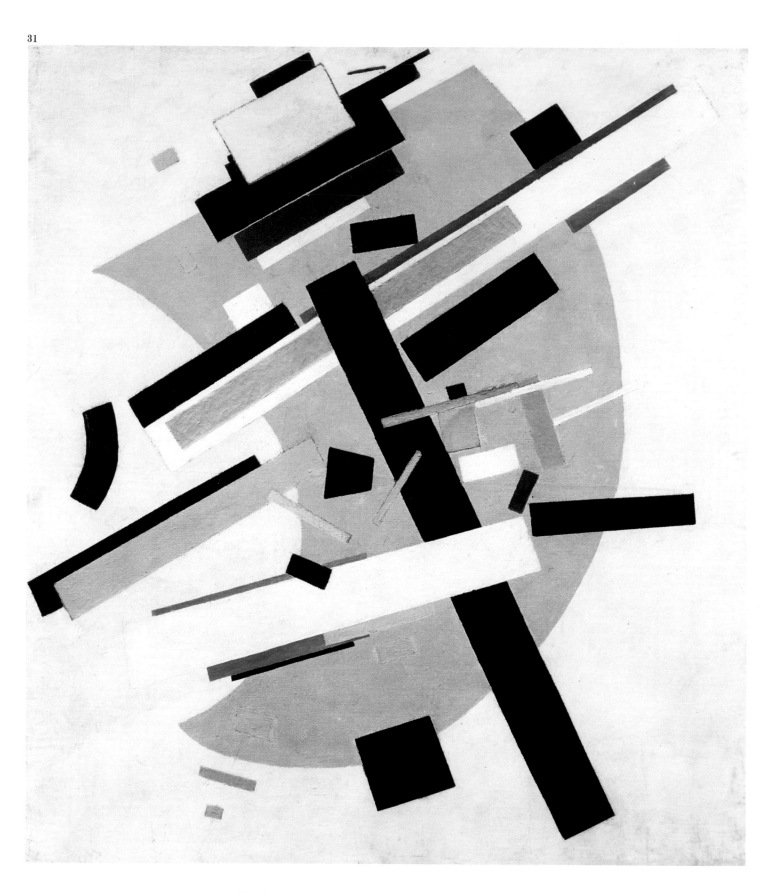

31 Suprematism (Supremus No. 58), *1916. As Malevich's new idiom developed, his regular shapes began to combine with others of a more organic form such as, here, the large curvilinear plane that unifies the composition. The dynamics of this work result from the tension between the gravity of this large, organic form and the centrifugal expansion of the interwoven rectangles superimposed on it. Malevich is also playing with different textures in this painting; his yellow rectangles in particular are painted in heavy impasto.*

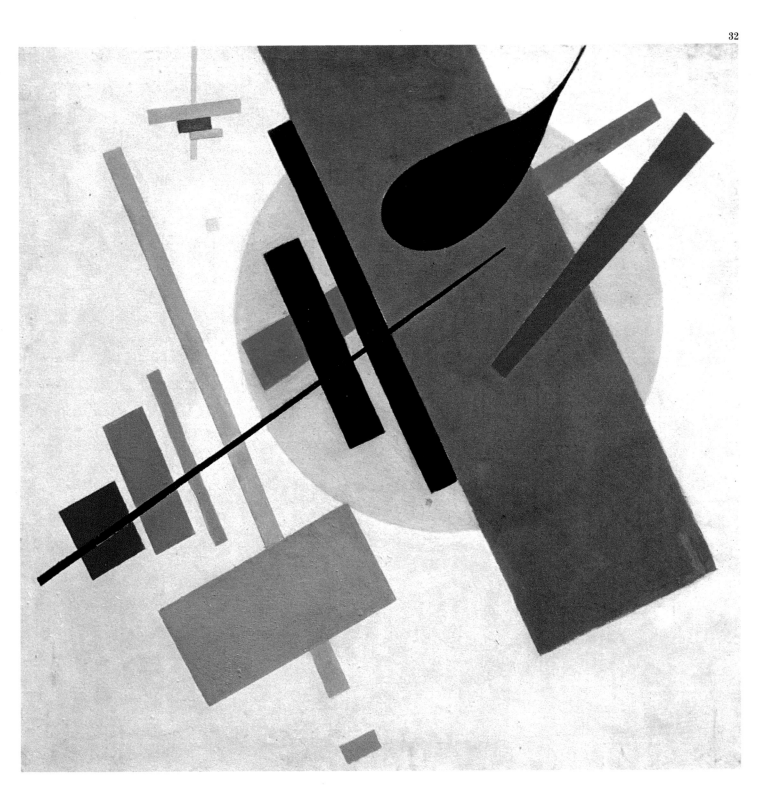

32 Suprematism, *1916–17. By 1915 the ever more complex forms
of Suprematist paintings began to affect their backgrounds.
Malevich typically used one large form, or a group of them—in
this case the circle and the large brown rectangle—to unify his
compositions. Here a diagonal black line skewers a series of
roughly parallel rectangles. Other non-representational artists of
the Russian avant-garde, especially El Lissitzky, would later adopt
this same motif.*

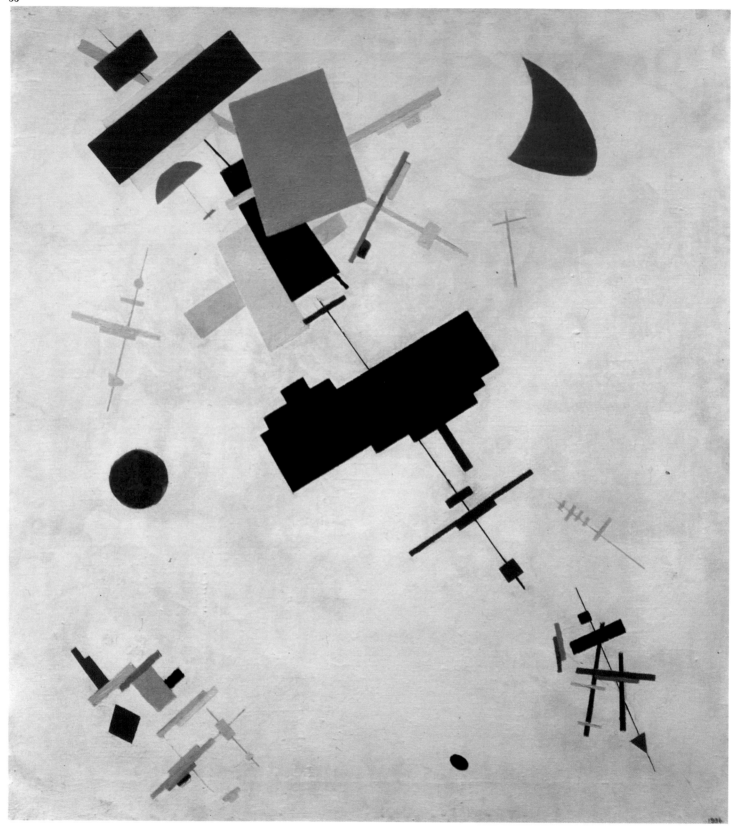

33 Supremus No. 56, *1916. The interaction of different scales is
another of Malevich's Suprematist devices. Here, a diagonal
structure threaded on an axis recurs in five distinct groupings. It
is as though the main motif were echoed in smaller variations
that retain its basic structure, but are resolved in different ways.*

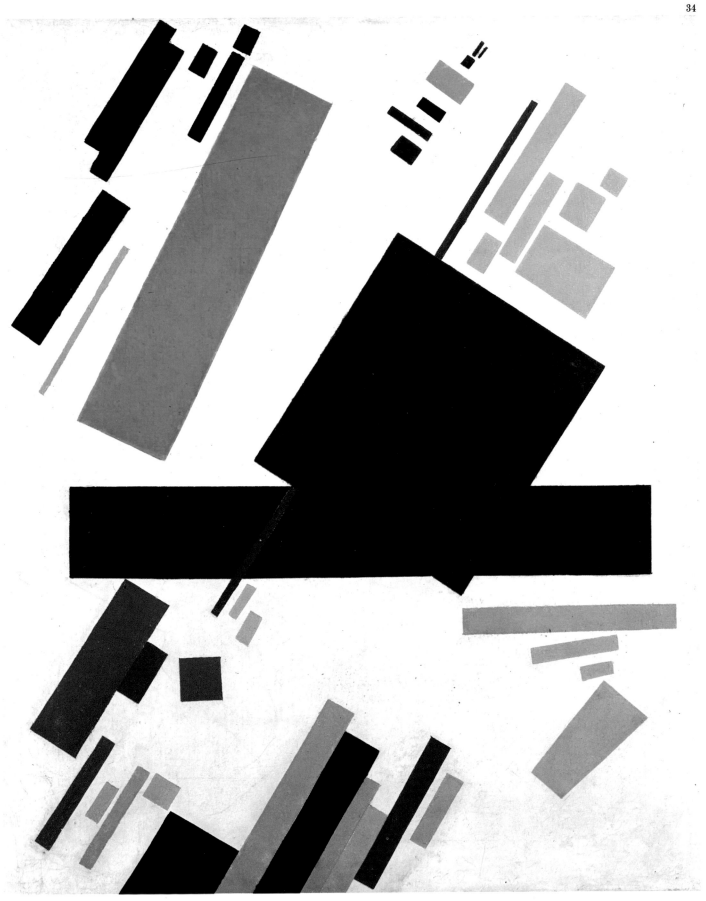

34 Suprematist Painting, *1916. The black rectangle at the center of the composition emphasizes the plane of the pictorial surface, over which the other shapes glide in diagonal ascent. Some of these are cropped by the edge of the painting, suggesting their continuity beyond its limits. Like* zaum *poems, which focus on the sonorities and rhythms of meaningless words, Suprematism creates rhythmic clusters of flat, colored form that refer to nothing other than themselves.*

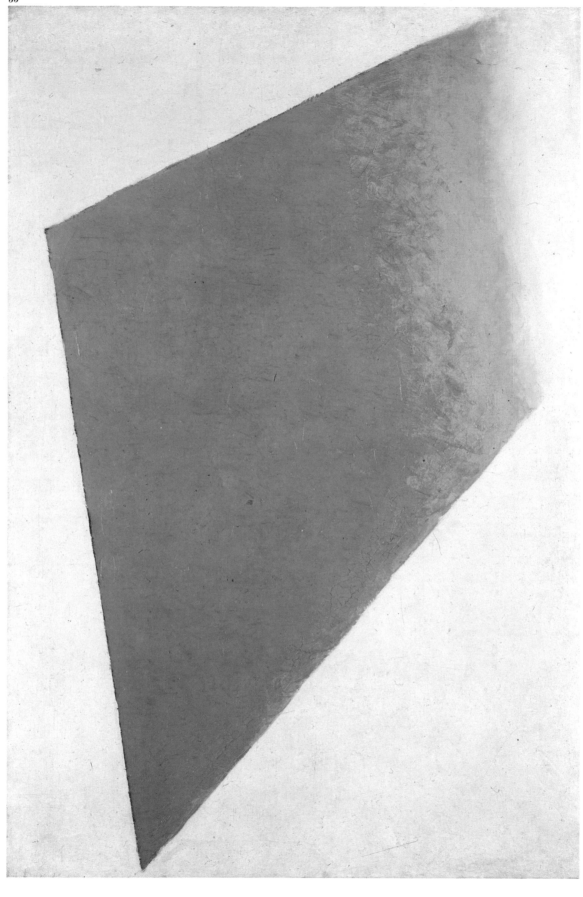

35 Suprematist Painting, *1917–18. In his last Suprematist paintings, Malevich exhibited a growing interest in the possibilities of blended tone and varied texture. Here, the relationship of the rhomboid form to the background is ambiguous. As the white ground merges with the golden tone of the rhomboid, it creates the illusion of a perpendicular plane sinking into the canvas. This anticipates one of the formal devices used by Mark Rothko and other American "color field" painters more than thirty years later.*

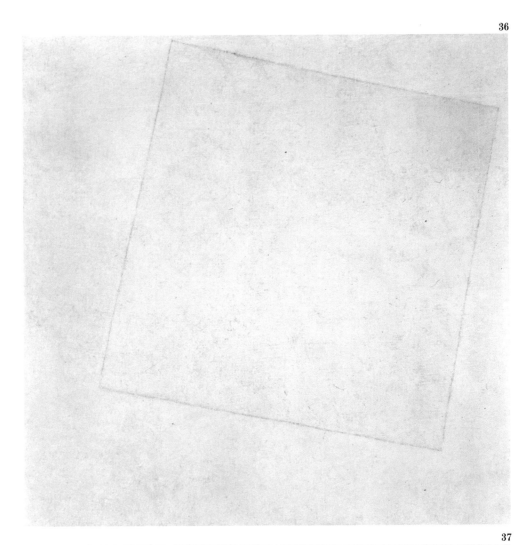

36, 37 Suprematist Composition:
White on White, *1918*. Suprematist
Composition, *1923–25*. *"One can
speak of creation,"* wrote Malevich,
*"only where form does not imitate
nature, but instead emanates from the
pictorial masses, without repeating or
modifying the primordial forms of
natural objects."* Between 1915 and
1920, the Suprematist idiom
developed considerably. Shapes
became more varied, and the
interplay of textures more noticeable,
while the pure colors of the earlier
works were joined by blended shades,
and the figures at times acquired an
outline. All these permutations
continued to unfold in a new pictorial
space, entirely separate from nature,
that had been generated by Black
Square.

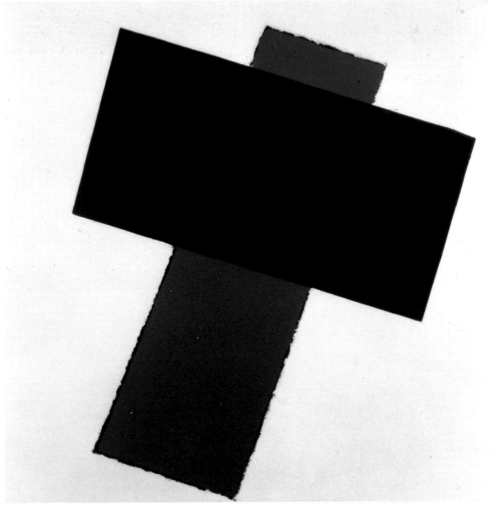

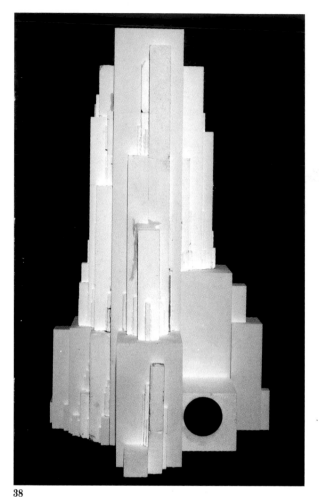

38

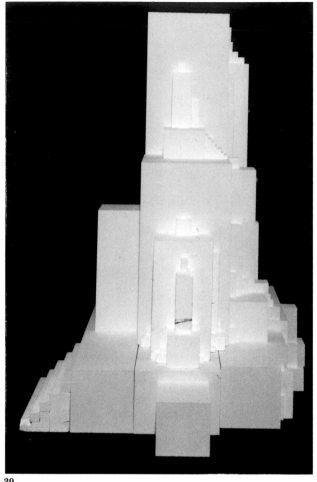

39

A Suprematist Mold

The Suprematist enterprise was a purely painterly one. Nonetheless, its very radicalness, and the possibilities it afforded to avant-garde discourse in the early years of Soviet Russia led Malevich to envision the possibility of "reshaping the world in a Suprematist mold." In 1918 he announced the extinction of easel painting and, between 1920 and 1922, developed the idea of applied Suprematism at UNOVIS (formerly the Vitebsk Art School). In 1924, as director of GINKHUK (the Petrograd State Institute of Artistic Culture), he turned his investigation to the making of architectural models, which he called "planits" or "architectonics." These models—initially drawings on paper, later produced as plaster maquettes—are not so much architectural projects as experimental proposals for the three-dimensional development of Suprematism. They were to occupy most of Malevich's time until he resumed painting in the late 1920s, and they show how firmly the Russian avant-garde had come to believe that the new world they had envisioned was indeed imminent.

38, 39 Drop, *ca. 1923.* Zee, *1923–27. As in painting, Suprematist sculpture developed from the formal matrix of the square, unfolding in space through a series of projections and displacements that generated rectangular and prismatic solids. Sometimes, as in* Drop, *Malevich painted black circles or crosses on the work for emblematic reasons.*

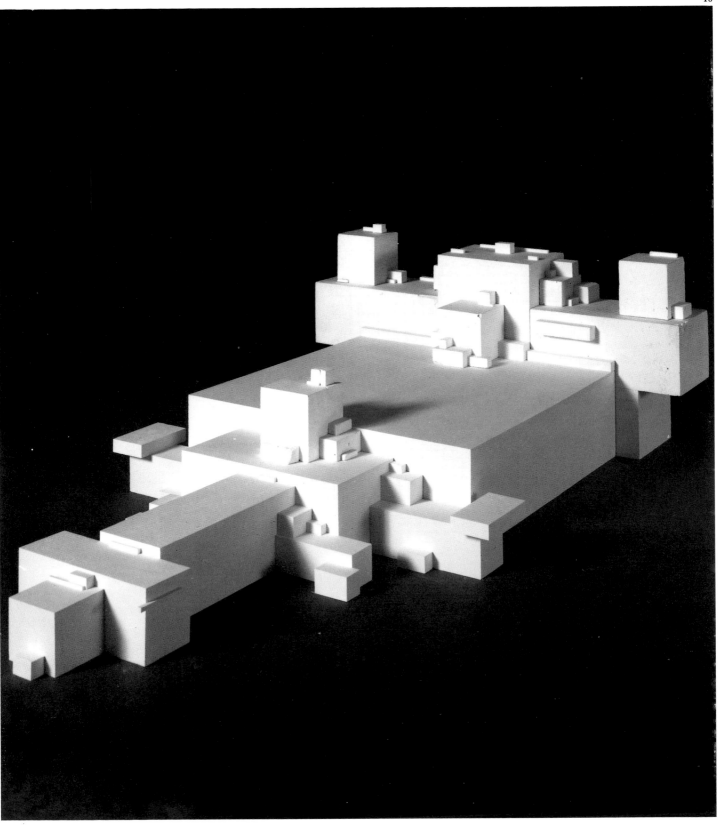

40 Beta, *before 1926. Malevich defined his "architectonics" as "architectural formulas, the forms of which can be conferred on buildings." Since they do not take into account any functional problem or issue of habitability, they are not quite experimental architecture, but rather ideal models for the application of Suprematist principles to architecture and urban design. Lissitzky, one of Malevich's most important followers during the UNOVIS years, would later develop similar concepts in his own geometric abstractions, the celebrated "Prouns."*

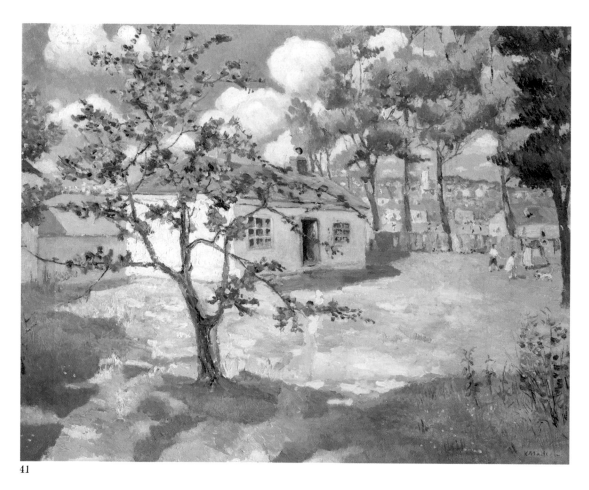

41

Revising the Origins

In 1927, Malevich traveled for the first and only time to the West. After a short stay in Poland, he made contact with a number of avant-gardists in Germany, including Walter Gropius and the artists of the Bauhaus. On this journey, Malevich carried along a number of his own works, with examples ranging from his early Post-Impressionist paintings to his most radical Suprematist experiments. He left all of these works on exhibition in Berlin when he returned to Russia; later most of them became part of the collections of the Stedelijk Museum in Amsterdam. In 1929, however, Malevich was granted a major solo exhibition at the prestigious Tretiakov Gallery in Moscow. With so many of his paintings still in Berlin, and wanting to document his career with examples from every period of it, he painted replicas of many of the works he had left in Germany. In making this reconstruction, however, he emphasized stylistic tendencies more in keeping with his current thinking, and even backdated some compositions, in effect revising the history of his own stylistic evolution. Thus he created a number of problems for later students of his work, both in dating individual works and in understanding his artistic trajectory.

41 Springtime, *after 1927. This re-creation by the artist of one of his early paintings shows his youthful fascination with Impressionist color. In his autobiographical writings, Malevich related that during his childhood, even before he developed any artistic perception, he always saw natural phenomena in terms of their color.*

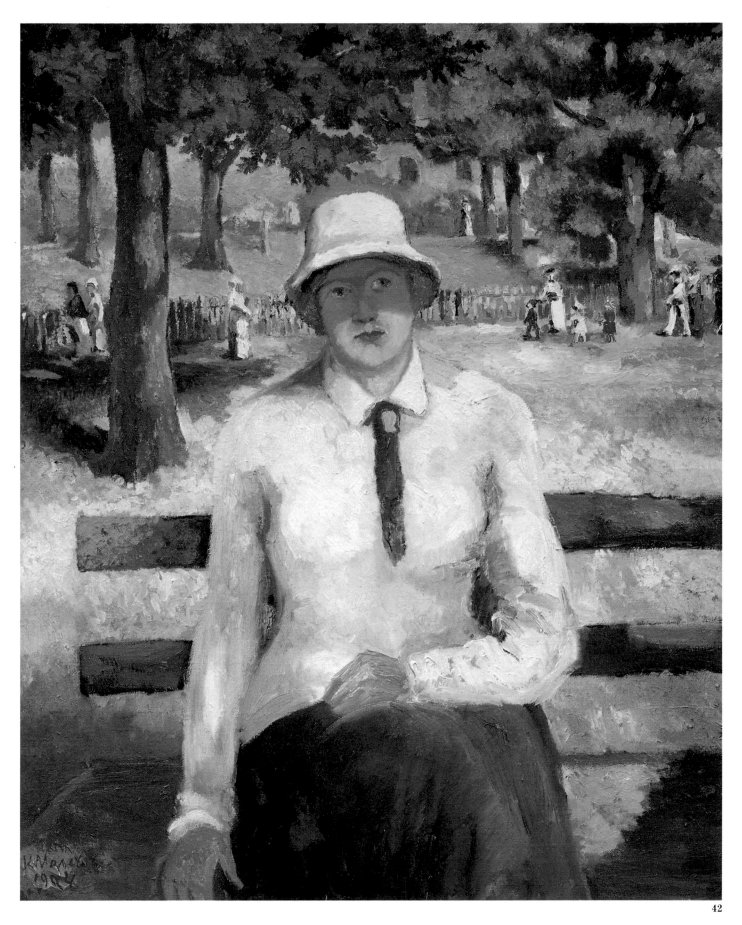

42 Unemployed Girl, *1904 (copy made in 1928 or later). Although Malevich dated this work to the beginning of the century, critics are unanimous in their belief that this is one of the replicas that the artist painted after his return from Germany in 1927. While the treatment of both color and figure reflects the Post-Impressionist and Nabi influence that prevailed in his works from his early years in Moscow, the subject corresponds to those of such paintings from that period as* On the Boulevard *(1911; no. 7).*

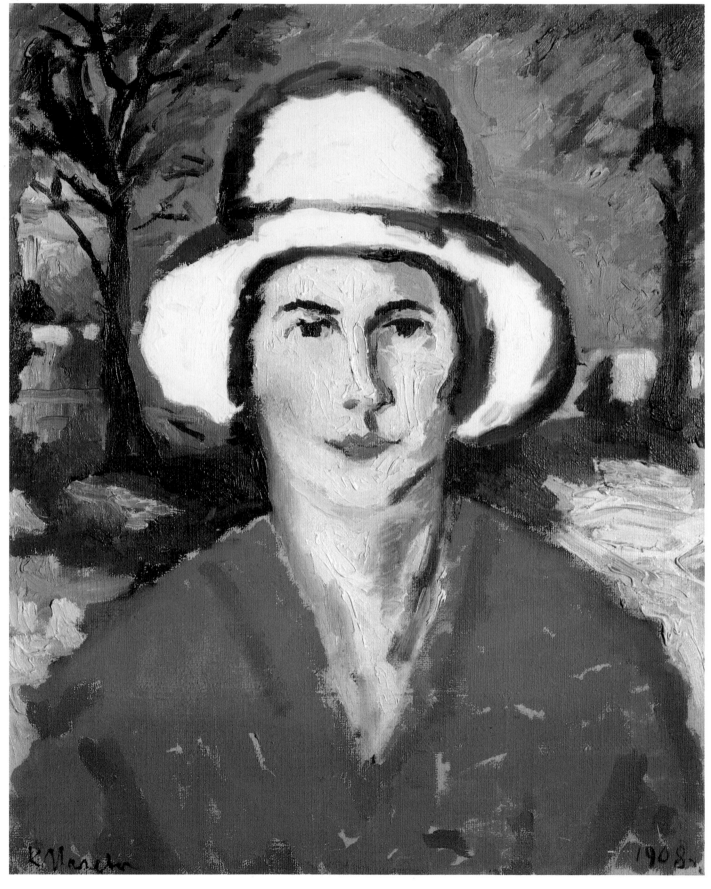

43 Woman in a Yellow Hat, *1908 (copy made in 1928 or later). This is yet another work that bears a date early in the artist's career, but that was actually painted at a much later time. It is a Fauvist image, very close to the examples that the artist might have seen in Russia around 1910, and strongly reminiscent of the work of Kees Van Dongen. In the revision of his artistic development that Malevich tried to leave to posterity, this work represents a transition from the naturalistic color of the Impressionists to an idiom that shows a greater independence from perception, and instead expresses the intrinsic necessities of the painting itself.*

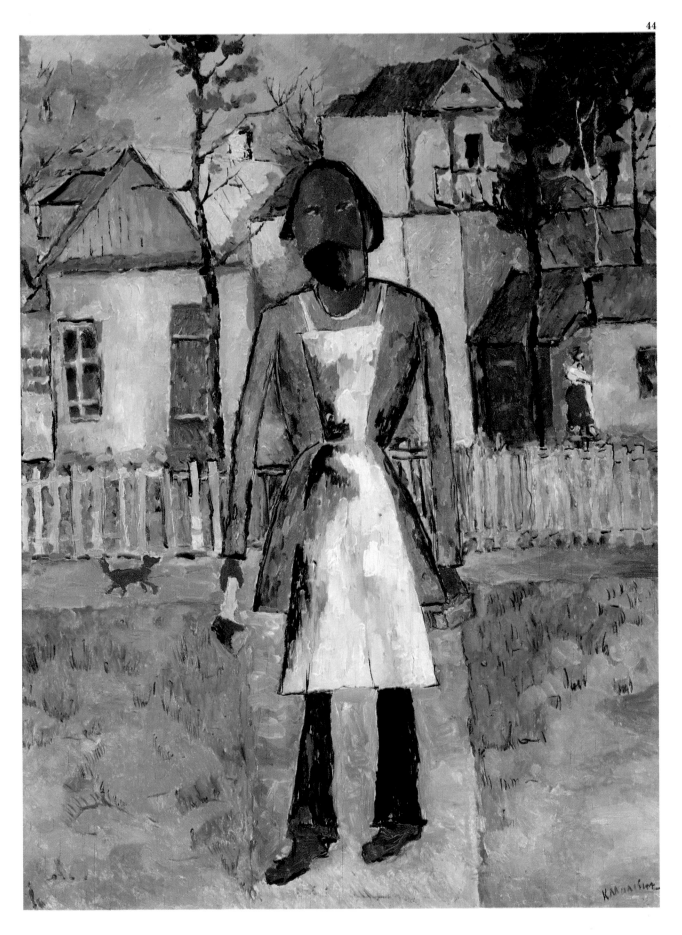

44 Carpenter, *1927. In this painting, Malevich combined some elements of his early work—Fauvist color, matted brushstrokes— with others typical of his late figurative period, such as the organization of space into juxtaposed planes, and the reduction of the figure's sketchy facial features to an oval composed of patches of color.*

Post-Suprematist Figurative Works

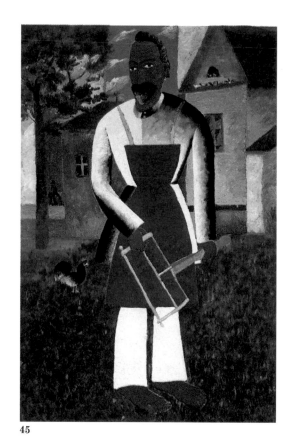

45

In the 1930s, the establishment of Socialist Realism as the official style of Soviet art virtually silenced the Russian avant-garde. The withdrawal of official favor not only gave rise to the legend that Malevich had been persecuted, but it also caused his late representational work to go almost unnoticed in the West until recently. Malevich's late paintings have generally been interpreted as the result of a coerced rejection of his avant-gardist past, but in fact the artist showed both his figurative and his Suprematist works in the same exhibitions, which suggests that he considered the two styles compatible. Thus, while *Black Square* had begun the development of an increasingly complex formal idiom, the later works may be seen as the consummation of an evolution in the opposite direction. El Lissitzky, who had been very close to Malevich in the Suprematist years, was among those who did not understand his shift in style. But even Lissitzky, in 1922, had written: "Hail to the valiant man who has hurled himself into the abyss in order to arise from the dead in a new form. After the pictorial line has decreased regularly...6, 5, 4, 3, 2, 1, all the way down to 0, on the other side of that cipher a new line begins: 0, 1, 2, 3, 4, 5...."

46

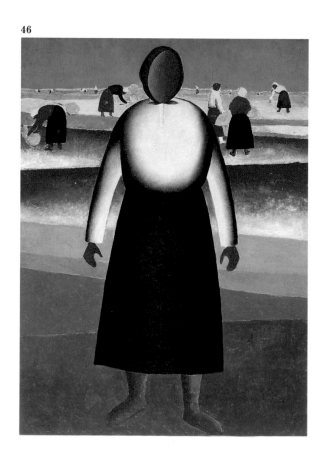

45, 46 At the Dacha, *after 1928*. The Harvest, *after 1928. With his return to figural painting, Malevich returned to certain features of his early Cubist years. His images of peasants are now tinged with a nostalgia for their traditional way of life, recently lost to the mechanization and collectivization of the Five Year Plans.*

47 Head of a Peasant, *ca. 1928–30. The icon is a constant presence in Malevich's oeuvre. Here the peasant is reduced to an immense Suprematist mask dominating a landscape laid out in stripes of color. The airplanes flying overhead allude to the conflict between the mythic timelessness of peasant life and the constant change introduced by twentieth-century technology.*

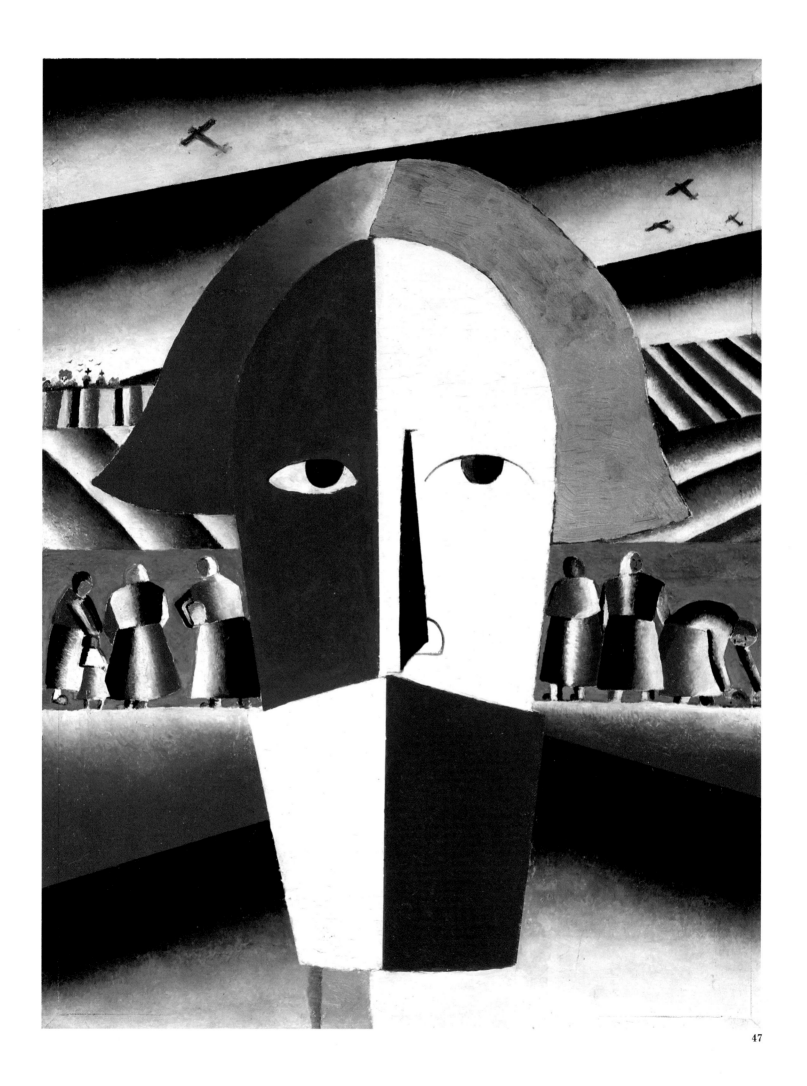

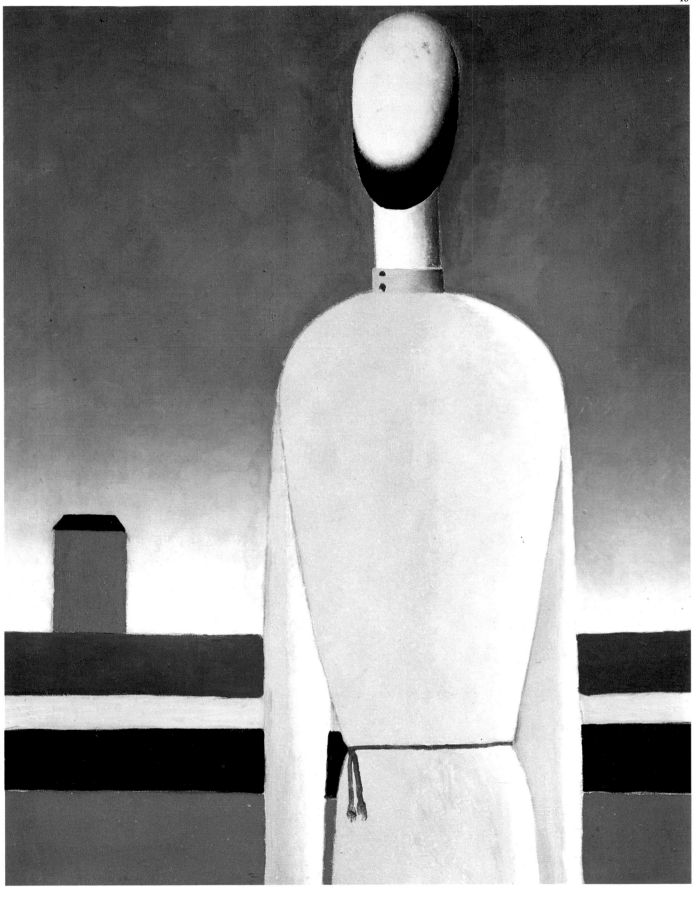

48, 49 Peasant in a Field, *ca. 1928–30.* Complex Premonition
(Bust in a Yellow Shirt), *1928–32. The connection of these two
paintings to the abstract Suprematist idiom of 1918–20 is
indisputable; the compositions are made up of geometric planes,
with little or no modulation of color. The only element that sets
them apart from the earlier works is their subject matter. Halfway
between heroes and robots, Malevich's faceless peasants markedly
resemble de Chirico's metaphysical mannikins. These emblems of
technological progress are abstract counterparts to the muscular
workers characteristic of Socialist Realism.*

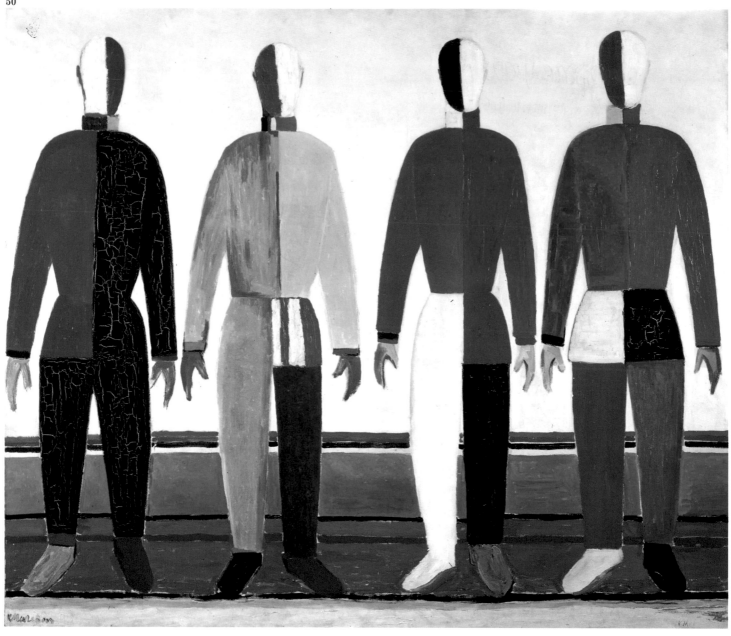

50 Sportsmen, *1928–30. The paintings of this period should be seen, at least in part, as an artistic search for the face of modern life. While in the early years of the Revolution Malevich's faith in the new society radiated a utopian optimism, his search is now tinged with uncertainties. Here, the artist has returned to the Futurist fascination with sport as an emblem of modern dynamism. Although formally these sportsmen recall some of the costumes for* Victory over the Sun, *their static and iconic presence is new.*

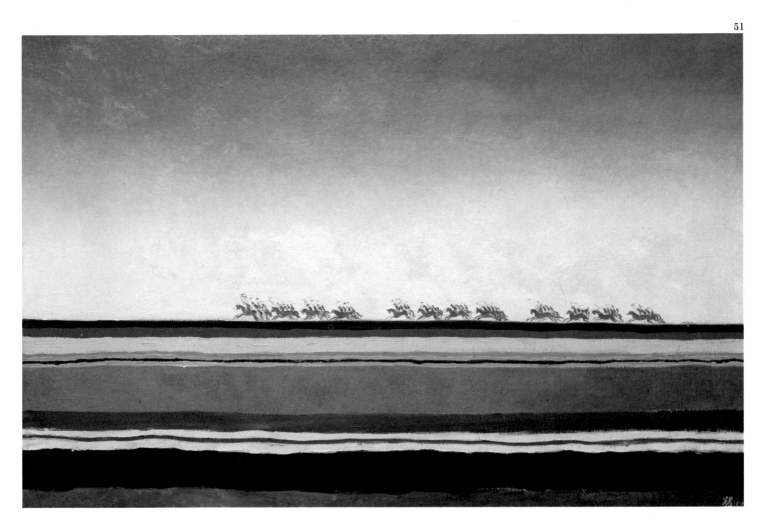

51 The Red Cavalry, *1930–31. In keeping with the legend that Malevich was forced to conform to the prevailing reactionary artistic directives of the Soviet state, the motif of the red cavalry has been seen as an addition imposed on a painting originally conceived as an abstract work. This belief is contradicted by the existing sketches for the work, all of which include the figures of the horsemen. However, this very misconception paradoxically reveals how close this peculiar type of figuration is to Malevich's earlier work. Hence, one can legitimately argue that the symbolism of the galloping riders is endowed with a significance much more universally poetic than its strictly political connotation.*

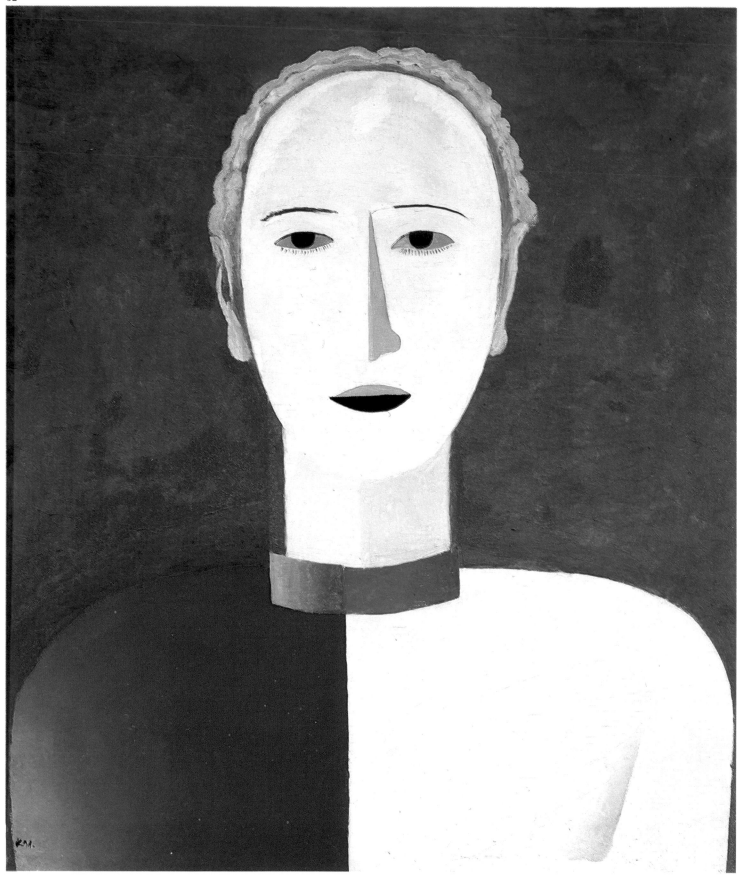

52, 53 Portrait of a Woman, *1928–32.* Half-length Portrait (Bust), *1928–32. As in his Suprematist phase, Malevich here alternates planes of pure color laid on in varying densities. Iconographically, he has returned to the themes and formulas of his work before 1915—in* Reaper against a Red Background *(no. 11), for instance—but their formal treatment and enigmatic meaning cannot be understood apart from the purifying and reductive process that preceded Suprematism.*

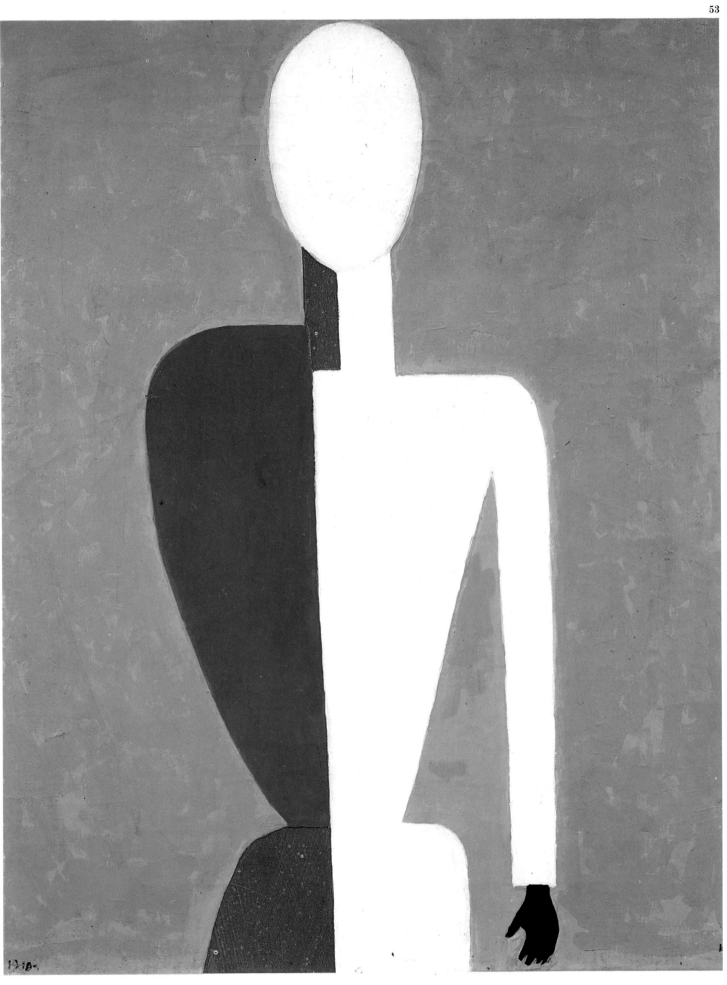

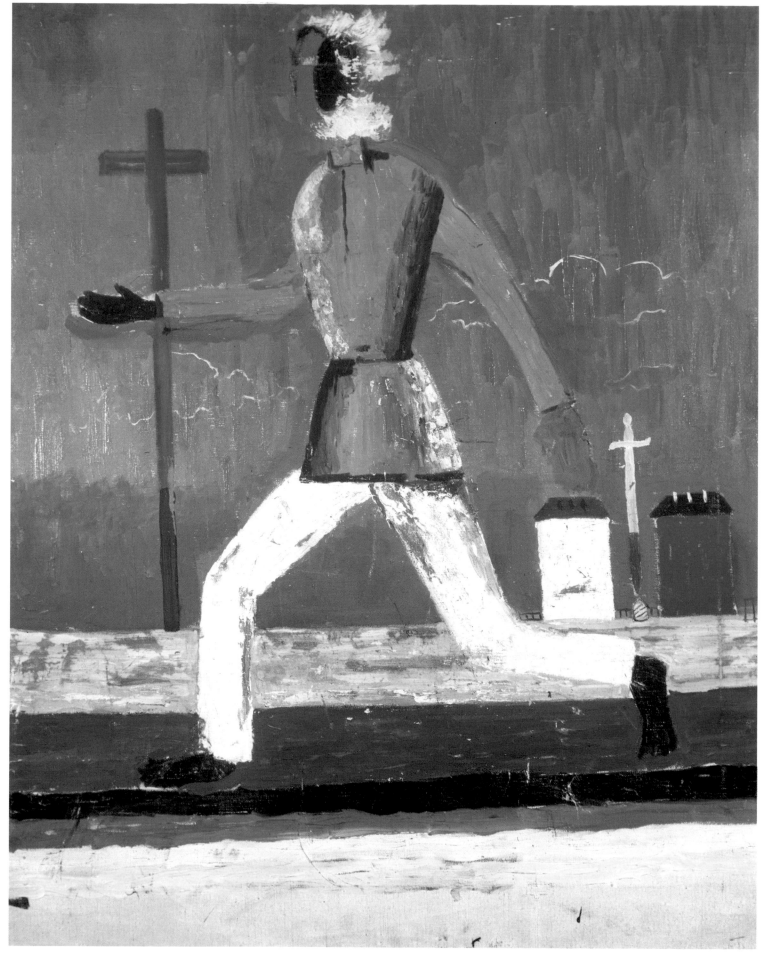

54 Running Man, *1932–34. The Expressionistic feeling of this picture is exceptional
among the figurative works of Malevich's last period. Subject and background,
composed of narrow bands of color that seem to transmit the figure's speed to the
landscape, are reminiscent of* The Red Cavalry *(no. 51). Painted after the artist's
detention in 1930, this picture seems to communicate something of the uneasiness
that he must have felt during the last years of his life.*

55 The Worker, *1933. Among the paintings from the last two years of the artist's life is a striking series of portraits, in which the naturalism of the faces and hands is offset by the abstract treatment of the drapery. These figures, however, are not individualized: they are emblems, as evidenced by the rigid hieraticism of their faces, and the conventional character of their gestures. Even at this stage of his life, Malevich was still painting icons.*

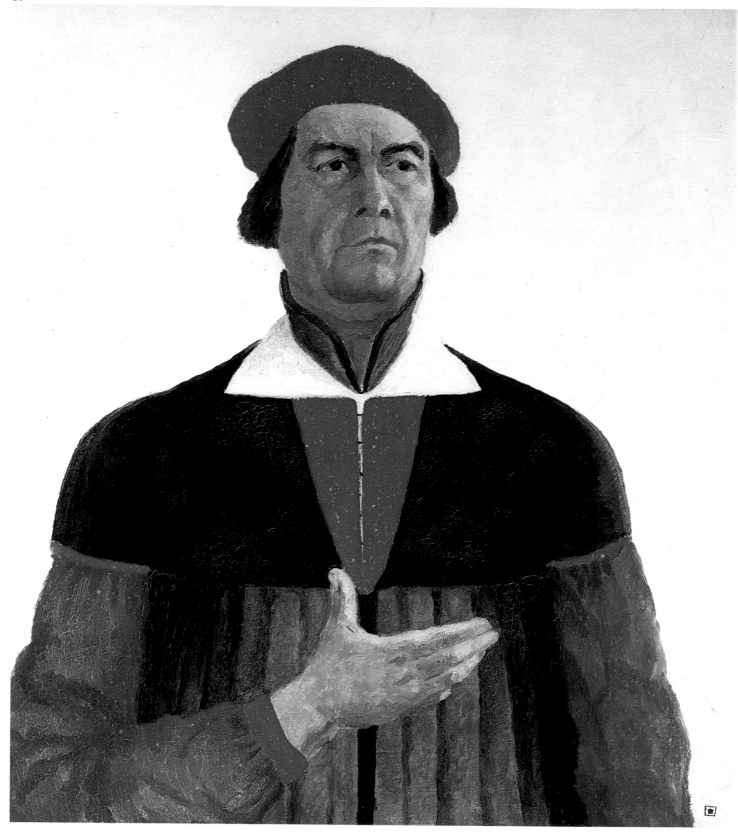

56 Self-portrait, *1933. In spite of its deceptive naturalism, this self-portrait is yet another icon. Feeling the unfavorable winds that were blowing against the realization of the avant-garde dream, Malevich portrayed himself dressed in an enigmatic garment that seems both to recall the past and to prefigure the future. Set against a bright and timeless background, his frozen face and gesture seem to depict a dreamer, the prophet of a utopia deferred or perhaps already proven impossible. Malevich signed this painting, as he did other works from these years, with his emblematic black square.*

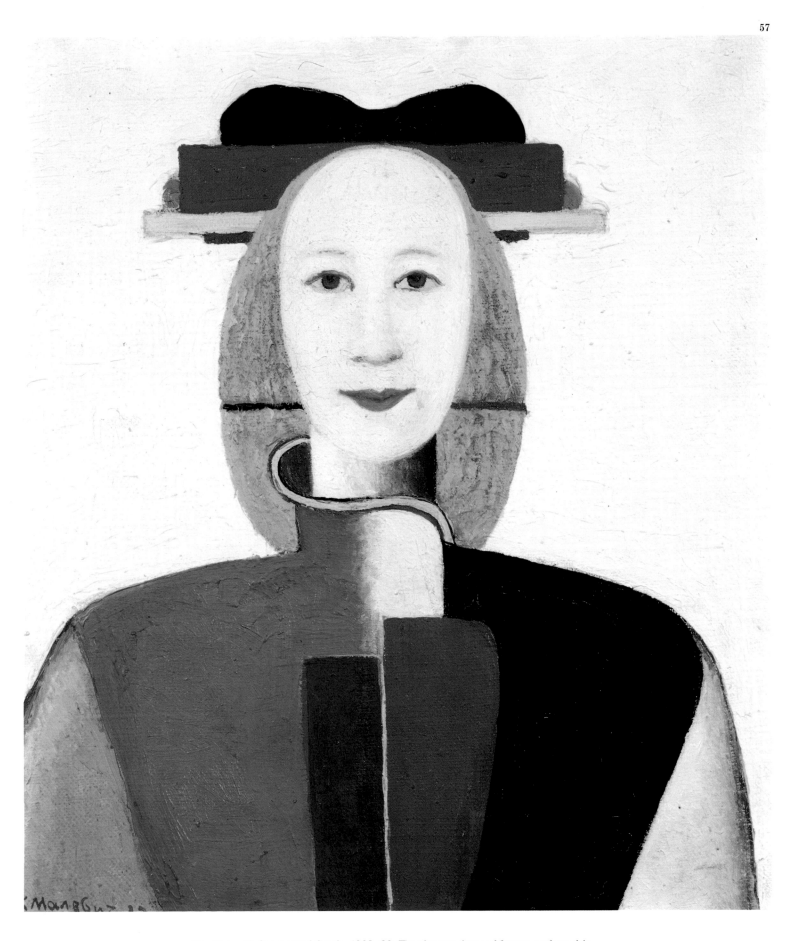

57 Girl with Ornamental Comb, *1932–33. The abstract dress of figures such as this one is based both on the costumes that Malevich had designed for the Russian avant-garde theater before 1920, and on the imagery of contemporary fantasy and science fiction movies. Unlike the figural paintings of the years before Suprematism, these images arise directly from painting itself; they belong to an intellectual universe without reference to anything outside itself.*

List of Plates

1 Portrait of a Member of the Artist's Family, *1906. Oil on canvas, mounted on panel, 26¾ × 39" (68 × 99 cm). Stedelijk Museum, Amsterdam*

2 Study for a Fresco (Self-Portrait), *1907. Tempera on cardboard, 27¼ × 27½" (69.3 × 70 cm). Russian Museum, Saint Petersburg*

3 Study for a Fresco, *1907. Tempera on cardboard, 27¼ × 28⅛" (69.3 × 71.5 cm). Russian Museum, Saint Petersburg*

4 The Leisure of High Society, *1908. Gouache, watercolor, and India ink on cardboard, 9⅜ × 11⅞" (23.8 × 30.2 cm). Russian Museum, Saint Petersburg*

5 Bathers, *ca. 1908. Oil on canvas, 23¼ × 18⅞" (59 × 48 cm). Russian Museum, Saint Petersburg*

6 Bather, *1911. Gouache on paper, 41¼ × 27⅛" (105 × 69 cm). Stedelijk Museum, Amsterdam*

7 On the Boulevard, *1911. Charcoal and gouache on paper, 28⅜ × 28" (72 × 71 cm). Stedelijk Museum, Amsterdam*

8 Peasant Woman with Buckets and a Child, *1912. Oil on canvas, 28⅜ × 28⅜" (73 × 73 cm). Stedelijk Museum, Amsterdam*

9 Woman with Water Pails: Dynamic Arrangement, *1912-13 dated 1912. Oil on canvas, 31⅝ × 31⅝" (80.3 × 80.3 cm). The Museum of Modern Art, New York. Photograph © 1996 The Museum of Modern Art, New York*

10 The Harvest of the Century, *1912. Oil on canvas, 28⅜ × 29⅜" (72 × 74.5 cm). Stedelijk Museum, Amsterdam*

11 Reaper against a Red Background, *1912–13. Oil on canvas, 45¼ × 27⅛" (115 × 69 cm). Fine Arts Museum, Gorky*

12 Head of a Peasant Woman, *1912–13. Oil on canvas, 31½ × 37⅜" (80 × 95 cm). Stedelijk Museum, Amsterdam*

13 Portrait of Ivan Kliun, *1912–13. Oil on canvas, 44⅛ × 27½" (112 × 70 cm). Russian Museum, Saint Petersburg*

14 The Knife Grinder, *1912–13. Oil on canvas, 31¼ × 31¼" (79.5 × 79.5 cm). Yale University Art Gallery, New Haven*

15 Portrait of Mikhail Matiushin, *1913. Oil on canvas, 41⅞ × 41⅞" (106.3 × 106.3 cm). Tretiakov Gallery, Moscow*

16 Transit Station: Kunsevo, *1913. Oil on panel, 19¼ × 10" (49 × 25.5 cm). Tretiakov Gallery, Moscow*

17 Cow and Violin, *1913. Oil on panel, 19¼ × 10⅛" (48.9 × 25.8 cm). Russian Museum, Saint Petersburg*

18 Private of the First Division, *1914. Oil on canvas with collage of postage stamp, thermometer, etc., 21⅛ × 17⅝" (53.7 × 44.8 cm). The Museum of Modern Art, New York. Photograph © 1996 The Museum of Modern Art, New York*

19 Partial Eclipse with Mona Lisa, *1914. Oil and collage on canvas, 24⅜ × 19½" (62 × 49.5 cm). Russian Museum, Saint Petersburg*

20 An Englishman in Moscow, *1914. Oil on canvas, 34⅝ × 22½" (88 × 57 cm). Stedelijk Museum, Amsterdam*

21 The Aviator, *1914. Oil on canvas, 49½ × 25½" (125 × 65 cm). Tretiakov Gallery, Moscow*

22, 23 *From* Suprematism, 34 drawings, *1920. Two lithographs, shown here in actual size, 5 × 4" (12.7 × 10.2 cm); 4⅛ × 3" (10.5 × 7.6 cm). UNOVIS, Vitebsk*

24 Black Square, *1923–29. Oil on canvas, 41¾ × 41⅞" (106.2 × 106.5 cm). Russian Museum, Saint Petersburg*

25 Black Circle, *1923–29. Oil on canvas, 41½ × 41½" (105.5 × 105.5 cm). Russian Museum, Saint Petersburg*

26 Black Cross, *1923–29. Oil on canvas, 41⅞ × 41⅞" (106.4 × 106.4 cm). Russian Museum, Saint Petersburg*

27 Red Square, *1915. Oil on canvas, 20⅞ × 20⅞" (53 × 53 cm). Russian Museum, Saint Petersburg*

28 Painterly Realism. Boy with Knapsack—Color Masses in the Fourth Dimension, *1915. Oil on canvas, 28 × 17½" (71.1 × 44.5 cm). The Museum of Modern Art, New York. Photograph © 1996 The Museum of Modern Art, New York*

29 Suprematist Compositon: Airplane Flying, *1915; dated 1914. Oil on canvas, 22⅞ × 19" (58.1 × 48.3 cm). The Museum of Modern Art, New York. Photograph © 1996 The Museum of Modern Art, New York*

30 Suprematism, *1915. Oil on canvas, 34½ × 28¼" (87.5 × 72 cm). Russian Museum, Saint Petersburg*

31 Suprematism (Supremus No. 58), *1916. Oil on canvas, 31¼ × 29½" (79.5 × 70.5 cm). Russian Museum, Saint Petersburg*

32 Suprematism, *1916–17. Oil on canvas, 31½ × 31½" (80 × 80 cm). Fine Arts Museum, Krasnodar*

33 Supremus No. 56, *1916. Oil on canvas, 31⅝ × 28" (80.5 × 71 cm). Russian Museum, Saint Petersburg*

34 Suprematist Painting, *1916. Oil on canvas, 34½ × 27½" (88 × 70 cm). Stedelijk Museum, Amsterdam*

35 Suprematist Painting, *1917–18. Oil on canvas, 41¾ × 27¾" (106 × 70.5 cm). Stedelijk Museum, Amsterdam*

36 Suprematist Composition: White on White, *1918. Oil on canvas, 31¼ × 31¼" (79.4 × 79.4 cm). The Museum of Modern Art, New York. Photograph © 1996 The Museum of Modern Art, New York*

37 Suprematist Composition, *1923–25. Oil on canvas, 31⅛ × 31⅛" (80 × 80 cm). The Museum of Modern Art, New York. Photograph © 1996 The Museum of Modern Art, New York*

38 Drop, *ca. 1923. Plaster, 33⅜ × 18⅞ × 22⅞" (85.2 × 48 × 58 cm). Musée National d'Art Moderne, Paris*

39 Zee, *1923–27. Plaster, 31¼ × 22⅜ × 28⅛" (79.4 × 56.7 × 71.4 cm). Musée National d'Art Moderne, Paris*

40 Beta, *before 1926. Plaster, 10¾ × 23⅛ × 39" (27.3 × 59.5 × 99.3 cm). Musée National d'Art Moderne, Paris*

41 Springtime, *after 1927. Oil on canvas, 20⅞ × 26" (53 × 66 cm). Russian Museum, Saint Petersburg*

42 Unemployed Girl, *1904 (copy made in 1928 or later). Oil on canvas, 31½ × 26" (80 × 66 cm). Russian Museum, Saint Petersburg*

43 Woman in a Yellow Hat, *1908 (copy made in 1928 or later). Oil on canvas, 18⅞ × 15⅜" (48 × 39 cm). Russian Museum, Saint Petersburg*

44 Carpenter, *1927. Oil on plywood, 28⅜ × 21¼" (72 × 54 cm). Russian Museum, Saint Petersburg*

45 At the Dacha, *after 1928. Oil on panel, 42½ × 28⅜ " (108 × 72 cm). Russian Museum, Saint Petersburg*

46 The Harvest, *after 1928. Oil on panel, 28⅞ × 20¼" (72.8 × 52.8 cm). Russian Museum, Saint Petersburg*

47 Head of a Peasant, *ca. 1928–30. Oil on panel, 28¼ × 21⅛" (71.7 × 53.8 cm). Russian Museum, Saint Petersburg*

48 Peasant in a Field, *1928–30. Oil on panel, 28 × 17¾" (71.3 × 44.2 cm). Russian Museum, Saint Petersburg*

49 Complex Premonition (Bust in a Yellow Shirt), *1928–32. Oil on canvas, 39 × 31⅛" (99 × 79 cm). Russian Museum, Saint Petersburg*

50 Sportsmen, *1928–30. Oil on canvas, 55⅞ × 64½" (142 × 164 cm). Russian Museum, Saint Petersburg*

51 The Red Cavalry, *1930–31. Oil on canvas, 35¾ × 55⅛" (91 × 140 cm). Russian Museum, Saint Petersburg*

52 Portrait of a Woman, *1928–32. Oil on panel, 22¾ × 19¼" (58 × 49 cm). Russian Museum, Saint Petersburg*

53 Half-length Portrait (Bust), *1928–32. Oil on canvas, 18⅛ × 14½" (46 × 37 cm). Russian Museum, Saint Petersburg*
54 Running Man, *1932–34. Oil on canvas, 31⅛ × 25½" (79 × 65 cm). Musée National d'Art Moderne, Paris*

55 The Worker, *1933. Oil on canvas, 28 × 23½" (71.2 × 59.8 cm). Russian Museum, Saint Petersburg*

56 Self-Portrait, *1933. Oil on canvas, 28¾ × 26" (73 × 66 cm). Russian Museum, Saint Petersburg*

57 Girl with Ornamental Comb, *1932–33. Oil on canvas, 13¾ × 12¼" (35.5 × 31 cm). Tretiakov Gallery, Moscow*

Selected Bibliography

Charlotte Douglas, *Kazimir Malevich*, Harry N. Abrams, New York, 1994.

Serge Fauchereau, *Malévich*, Ediciones Polígrafa, Barcelona, 1992.

Jean-Claude Mercadé, *Malévitch*, Nouvelles éditions françaises-Casterman, Paris, 1990.

Angelica Zander Rudenstine, ed., *Russian Avant-Garde Art: The George Costakis Collection* Harry N. Abrams, New York, 1981.

Malevich, exhibition catalog, National Gallery of Art, Washington, D.C. , 1990.

Malévitch, exhibition catalog, Editions du Centre Georges Pompidou, Paris, 1978.

Ecrits de Malévitch, ed. by Jean-Claude Mercadé, 4 vols., Editions de l'Age d'homme, Lausanne, 1974–1994.

Series Coordinator, English-language edition: Ellen Rosefsky Cohen
Editor, English-language edition: Elaine Stainton
Designer, English-language edition: Judith Michael

Library of Congress Catalog Card Number: 96–84006
ISBN 0–8109–4691–2

Printed and bound in Spain by La Polígrafa, S.L.
Parets del Vallès (Barcelona)
Dep. Leg.: B.11580–1996